Deanne Eisenman

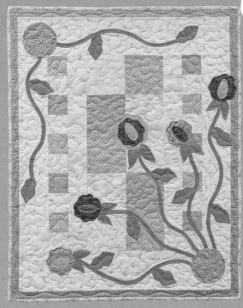

Country-Fresh
Quilts

Traditional Blocks
with Floral Accents

Martingale®
& COMPANY

Country-Fresh Quilts:
Traditional Blocks with Floral Accents
© 2008 by Deanne Eisenman

That Patchwork Place® is an
imprint of Martingale & Company®.

Martingale & Company
20205 144th Ave. NE
Woodinville, WA 98072-8478 USA
www.martingale-pub.com

Printed in China
13 12 11 10 09 08 8 7 6 5 4 3 2 1

Library of Congress
Cataloging-in-Publication Data
Library of Congress Control Number:
2008014035

ISBN: 978-1-56477-821-5

MISSION STATEMENT

Dedicated to providing quality
products and service to inspire creativity.

CREDITS

President & CEO: Tom Wierzbicki

Publisher: Jane Hamada

Editorial Director: Mary V. Green

Managing Editor: Tina Cook

Developmental Editor: Karen Costello Soltys

Technical Editor: Laurie Baker

Copy Editor: Marcy Heffernan

Design Director: Stan Green

Production Manager: Regina Girard

Illustrator: Adrienne Smitke

Cover & Text Designer: Regina Girard

Photographer: Brent Kane

Contents

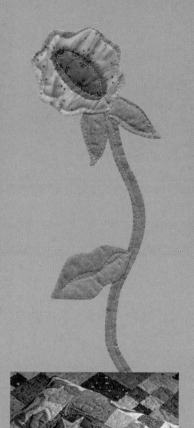

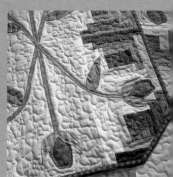

Blooms in the Cabin

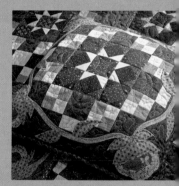

Star Garden

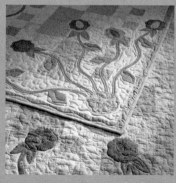

Patchwork Blooms

Pastel Blooms

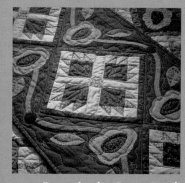

Bears in the Berry Patch

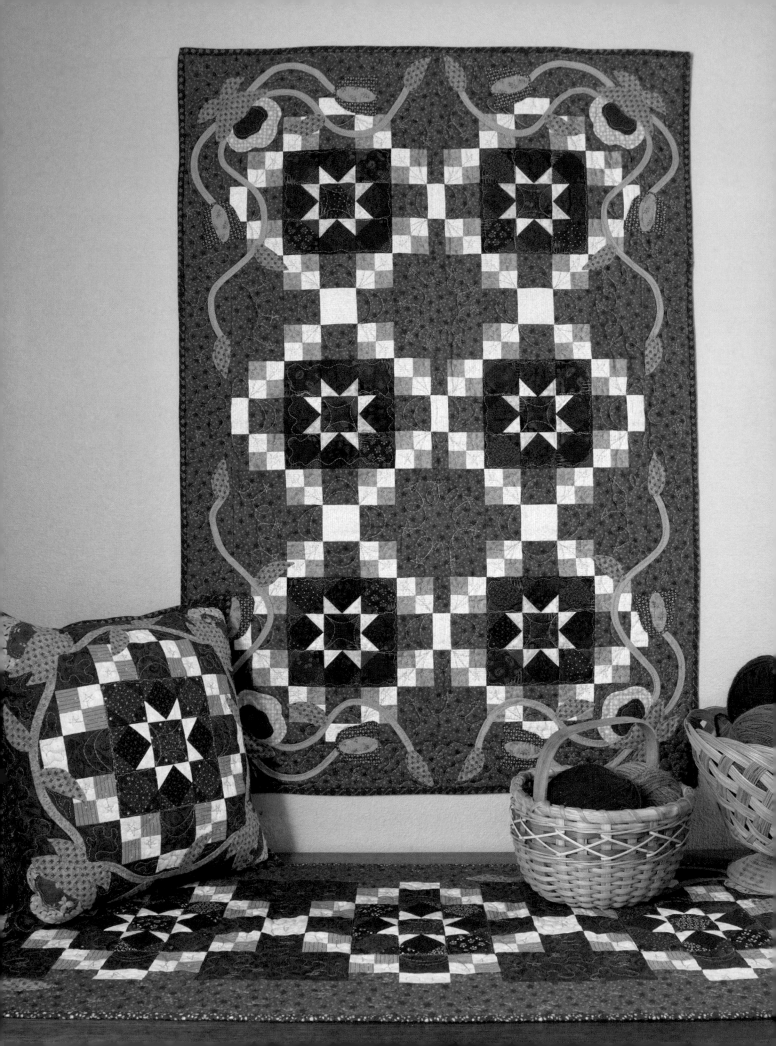

Introduction

Many striking quilts are simply a creative blend of easy patchwork and colorful appliqué. I have designed many quilt patterns using patchwork, with both traditional and original blocks, and appliqué for several years. Appliqué adds a special character to traditional blocks and makes the design come alive. The projects in this book join floral appliqué and traditional patchwork blocks to make fun and colorful quilts. I hope you enjoy making them as much as I did—and enjoy displaying them as well!

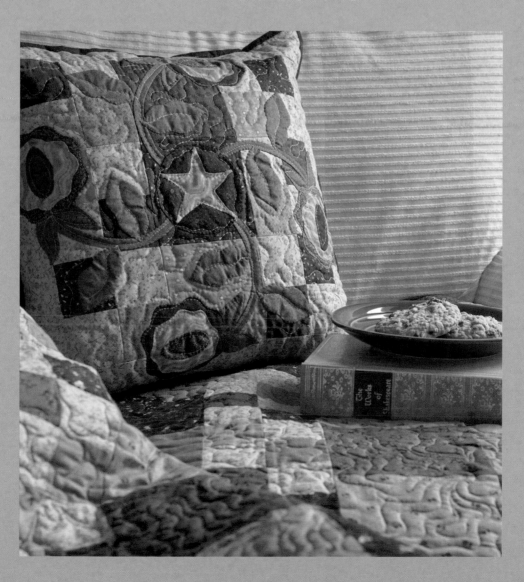

Quiltmaking Instructions

I have been quilting for more than 18 years, since taking a 10-week adult education class for fun. Shortly after taking that class, I caught the bug—the "quilting" bug that is! All other crafting I had done up to that point seemed to pale in comparison to the art of quiltmaking. Many of the tips and techniques I share in this section come from my years as a student of quilting. I am always learning and finding ways to make things easier. Sometimes I'll stumble upon a technique and wish I had learned it years ago! Most of the time, the things I learn come from other quilters in my small quilting group or from fellow guild members. You never know where the next great idea will come from!

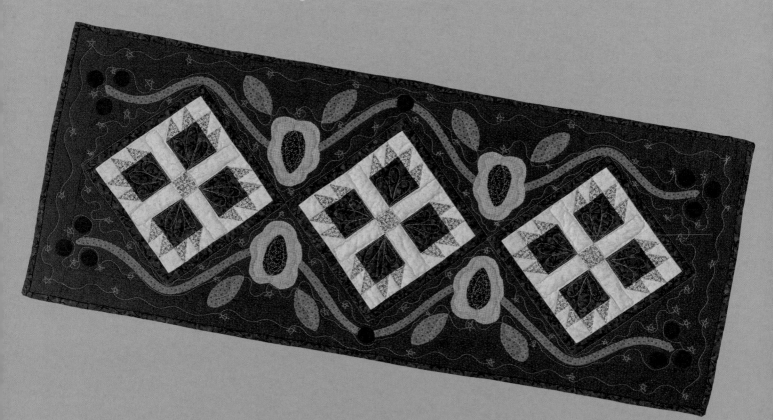

Prewashing Fabric

Prewashing your fabric prior to cutting out the pieces is a matter of personal preference. I generally prewash my fabrics if they will be used in a project that will be laundered often or if I'm worried about shrinkage or excess dyes in the fabric. I wash fabric on the gentle cycle, careful to separate darks and lights, and tumble dry on low. I remove the fabric from the dryer when it is still slightly damp and then press it to remove wrinkles. If you like the "antique" look that fabric shrinkage creates, then you may not want to prewash. To minimize fraying, consider trimming the raw edges with pinking shears before washing.

Rotary Cutting

Except for appliqué template pieces and where noted, all cutting instructions for the projects in this book are for rotary cutting. All measurements include ¼"-wide seam allowances.

Squaring Fabric

Squaring fabric is a necessary step that ensures the strips you cut from your fabric are straight. Follow these steps to square each piece of fabric before you begin cutting the required pieces. (If you are left-handed, reverse the ruler position so that you are squaring the right edge of the fabric.)

1. Fold the piece wrong sides together, matching the selvage edges. The selvage edges are the lengthwise finished edges of the fabric. Lay the piece flat on a cutting surface with the fold nearest to you. It does not matter if the raw edges on the sides match up.

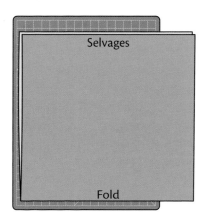

2. Lay a square ruler on the fabric, lining up the bottom of the ruler with the edge of the fabric fold. Butt a long ruler against the left edge of the square ruler, making sure the fabric raw edge is under the long ruler.

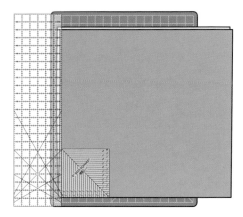

3. Remove the square ruler, being careful not to move the long ruler. With your hand on the long ruler to keep it stationary, place your rotary-cutting blade against the ruler and begin cutting at the bottom fold. Cut along the entire width of the fabric. Discard the scrap. Your fabric is now ready for cutting.

Cutting Tips

- Before starting a project, make sure your rotary blade is sharp. A dull blade will cause skips in the cutting and make it harder to cut in general. If you find you have to press down hard to get a decent cut, your blade is probably ready for replacement.

- Remember the old adage "measure twice, cut once." The projects in this book allow some additional fabric for shrinkage and errors, but other designers' patterns may not. If you are not sure of your cutting skills or whether the pattern you are using allows for extra fabric, you may want to add an additional ⅛ yard to the required amount for "wiggle room." It's a good idea to cut and then label all your pieces with the dimensions prior to sewing. I like to do this so that I am sure I have enough fabric up front. No surprises!

- I like to cut the widest strips and width-of-fabric strips first. This way if there is fabric left from a wider or longer strip, a smaller piece can be cut from it. I find there is less fabric waste this way.

Straight Strips and Squares

Once your fabric is squared, you can cut strips from the straightened edge. Unless stated otherwise, strips are cut on the crosswise grain, which is selvage to selvage. This is also known as a width-of-fabric strip. Occasionally you will be asked to cut lengthwise-grain strips, which are cut parallel to the selvage. Lengthwise-grain strips are often used when cutting long border strips for large quilts because they are more stable than crosswise-grain strips. If you need to cut lengthwise-grain strips, square the lengthwise edges first, making sure you remove the selvage edges, and then cut the strips from the straightened edge.

1. Place your ruler on the fabric, aligning the ruler line for the desired strip width with the straightened edge. Cut a strip. Repeat until you have cut the desired number of strips.

2. To cut squares from the strips, rotate the folded strip so that the selvage edges are to your left, and then square up the strip in the same manner as you squared up the yardage.

3. Align the desired line on the ruler, which will be the same as the strip width, with the straightened edge. Cut across the strip. Because the strip is folded, each cut will yield two squares.

Triangles

Some of the projects in the book require half-square and quarter-square triangles. These triangles can be cut from squares that have been cut from straight strips. The first step will be to cut the desired strip size, and then cut squares from the strips.

To cut half-square triangles, cut each square in half diagonally, corner to corner, to yield two triangles.

Half-square triangles

To cut quarter-square triangles, cut each square diagonally in both directions to yield four triangles.

Quarter-square triangles

Machine Piecing

Along with cutting accurately sized pieces, using proper techniques for machine piecing and pressing will help you achieve a successful finished project. In this section you'll find my thoughts on these subjects, as well as instructions for techniques used throughout the book.

Accurate Seam Allowances

A general quilting rule, unless otherwise stated in a pattern, is that a ¼" seam allowance is used when sewing two pieces together. The patterns in this book and most patterns on the market figure the ¼" seam allowance into the measurements of the pieces you cut. When piecing with your machine, be sure you are sewing a consistent ¼" seam allowance. A small amount off one way or the other will become magnified as you continue piecing.

There are several ways you can achieve a ¼" seam allowance. Some machines have a mark etched into the throat plate indicating where the edge of your fabric should be for a ¼" seam allowance. If not, you can create your own guideline using masking tape. To do this, lay a fabric tape measure on the bed of your machine with the "0" line at the point where the needle comes down. Stick a piece of masking tape to the throat plate, under the tape measure, aligning it with the ¼" mark on the tape.

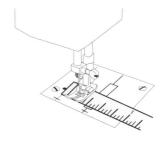

When piecing, line up the raw edges of your fabric with the mark and sew. It's a good idea to do a few practice pieces and measure the resulting seam to make sure it is ¼".

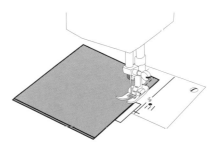

An alternative to a guideline marked on your machine is to use a ¼" presser foot made specifically for your machine. Many machines also have adjustable needle positions that can be used to achieve an accurate seam allowance.

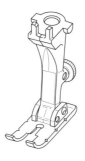

Whatever method you choose, always test for accuracy. Once I have finished a pieced unit or block, I measure it to see if it is the size the pattern states. By checking measurements as you go, you'll save yourself from many headaches and from spending a lot of time ripping out seams and resewing. Believe me, I was once a champion unsewer until I started checking measurements along the way.

Machine-Piecing Tips

- Make sure your sewing-machine needle is in good shape before beginning a project. It's usually a good idea to change your needle after each project. The wear and tear on the needle may not be noticeable to you, but it's there.
- I usually use a light-colored neutral thread to piece my tops, unless I'm making a very dark quilt. In that case, I use a dark color that blends in, such as brown or black.

Pressing

I must admit, I tend to be a little unorthodox in some of my quilting techniques because I have been mainly self-taught. Yes, I am *that* quilter who presses her seams open. I guess I got into the habit of doing it that way and can't break myself of it. I haven't had any problems, like seams on a completed quilt coming apart, so I continue this way. However, the general rule in quilting is to press the seam allowances to one side (usually toward the darker fabric if possible), with the seam allowances of pieces that will be joined pressed in opposite directions. Seams with allowances pressed to one side are generally stronger than seams with allowances pressed open, and seam allowances pressed in opposite directions are easier to match up. Sometimes it is just not possible to press toward the darker fabric, so I usually tell quilters to press the seams as needed to produce the least amount of bulk.

Folded-Corner Technique

In many of the patterns in this book, I use the folded-corner technique to add an angled piece to the corner(s) of squares or rectangles. In fact, this technique is what creates the unique design in the "Star Garden" pattern, beginning on page 27. With folded corners, you can create complicated-looking units using just squares and rectangles.

1. Fold the square in half diagonally, wrong sides together, or draw a diagonal line from corner to corner on the wrong side of the square. This square will be smaller than the square or rectangle to which it will be sewn.

2. With right sides together, lay the marked square in the corner of the larger square or rectangle with the line positioned as shown. Line up the raw edges. Sew on the marked line. Trim ¼" from the stitched line. Press the resulting triangle toward the corner and press the seam allowance open. Repeat on as many corners of the square or rectangle as instructed for the project.

 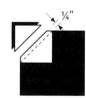

Strip Sets

Some patterns in this book will have you assemble a strip set. A strip set has two or more fabric strips that are joined along their longest edges, and then smaller pieces are cut from the joined set. This is a quick way to make pieces for four-patch or nine-patch units or blocks, instead of having to piece together each individual square.

Appliqué

There are many techniques for appliqué and it would take many pages to describe them all, so I have chosen to give you one hand-appliqué method and one machine-appliqué method, as well as instructions for making bias stems. Use one of these techniques or your own preferred method with any pattern that has appliqué. Appliqué patterns do *not* include seam allowances.

Needle-Turn Hand Appliqué

I took a few classes in hand appliqué before ever doing any type of machine appliqué, so I like doing hand appliqué the best. Oddly enough, it's the way I relax! That probably seems funny to those of you who are afraid of the "A word," as appliqué is sometimes called. You will need appliqué needles, template material (I use paper, or cardstock if the template will be used several times), scissors for cutting out the template, chalk pencils, small sewing scissors, thread that matches the color of the appliqué piece, water-soluble fabric glue, and very good lighting.

1. Trace the pattern onto the template material and cut it out.

2. Lay the template on the right side of the appropriate fabric and trace around it with a chalk pencil.

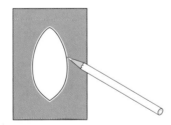

3. Cut out the shape from the fabric, adding a scant ¼" seam allowance.

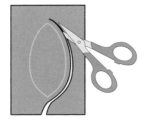

4. Clip from the seam allowance up to the drawn line. Clips should be about 1" apart in straight areas and about ⅛" apart in curved areas. Clipping helps the appliqué maintain its shape when you turn under the seam allowances while sewing.

5. Dot the wrong side of the appliqué piece with just enough fabric glue to hold the appliqué piece in place so that it doesn't shift while stitching. Do not apply any glue in the seam allowance. Position the appliqué piece on the background fabric where indicated.

6. Turn under a small portion of the seam allowance. Thread your needle and knot one end. Bring the needle up from the wrong side of the fabric, catching a few threads on the edge of the appliqué. Then, insert the needle into the background fabric right next to where it came up but slightly underneath the appliqué. This creates a tiny blind stitch. Continue in this manner, turning under a small portion of seam allowance at a time and taking stitches about ⅛" (or less) apart. Any wider distance between stitches can create puckers in the appliqué piece. Make a small knot on the back of the piece when you have stitched down the entire piece.

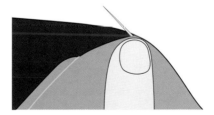

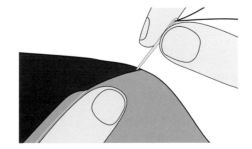

Fusible-Web Machine Appliqué

I admit that I am not an expert in machine appliqué and use it very rarely, even though it generally is an easier and quicker method. The main difference from hand appliqué is that the appliqué piece is cut out without adding a seam allowance. The piece is then positioned on the background, adhered with fusible web, and then stitched around. You will need light-weight, paper-backed fusible web and clear thread if you want the stitches to be invisible; use contrasting thread if you prefer that the stitches show. Because this process will produce shapes that are the reverse of the pattern, you will need to make a mirror image of any shapes that are not symmetrical. You can do this by tracing the pattern onto a piece of copy paper, and then turning the paper over and tracing the pattern through to the blank side.

1. Trace the reversed patterns onto the paper side of the fusible web as many times as needed for each pattern. Leave about ½" of space between the motifs.

2. Cut out each shape roughly ¼" outside the drawn lines. If you will be cutting more than one motif from the same fabric, cut out the group as a unit.

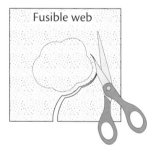

Fusible web

3. Place the fusible-web shapes on the wrong side of the appropriate fabrics. Follow the manufacturer's instructions to fuse the shapes in place. Cut out each shape on the traced line.

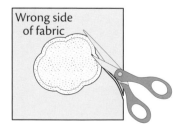

Wrong side of fabric

4. Remove the paper backing from the appliqué shapes. Position each shape on the background fabric where indicated, web-side down, and press it in place with your iron.

5. Use a narrow zigzag stitch, blanket stitch, or other decorative stitch to stitch around the outside edges of each appliqué to permanently secure it.

Making Bias Stems

Because the strips are cut on the bias, they stretch easily, making them ideal to use in appliqué for stems that need to curve. The patterns in this book cut bias strips from fat eighths or fat quarters. The strips are cut 1" wide and finish to ½".

1. Iron your piece of fabric to remove any wrinkles or folds.

2. Lay the fabric on the cutting surface with the longest edge closest to you. Place the 45° angle mark of the ruler along the fabric's bottom edge. If your ruler is not long enough to go the entire length of the fabric piece, butt another ruler against the end of the first so you have a continuous cutting guide. Once you have the ruler(s) aligned, hold it in place with your hand and make the diagonal cut with the rotary cutter.

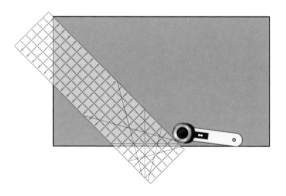

3. Align the 1" line on your ruler with the cut edge. Cut a strip. Cut as many strips as necessary to reach the total required length.

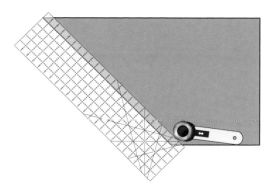

4. Once the strips are cut, you can trim them to the length needed or piece them together at right angles to achieve the required length.

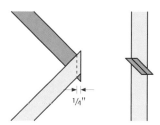

Press seam open.

5. To make stems from bias strips, press under ¼" on both long sides of the strip so that the raw edges meet in the center on the wrong side of the strip. A bias tape maker or pressing bar makes this task easier.

6. Place the stem on the background fabric, raw edges down. Machine or hand appliqué the stem in place along the long edges, beginning with the side that curves inward.

Finishing Techniques

Completing your quilt top is a big accomplishment, but there are a few more steps to take care of before your quilt is finished.

Layering the Quilt

To prepare the quilt for quilting, you need to layer the quilt top with batting and backing to make the "quilt sandwich." The backing and batting pieces need to be at least 4" larger on each side than your quilt top. For larger quilts, you may need to piece two or three lengths together to make a backing that is large enough. The yardage given in the materials list for each project is based on 42"-wide fabric, but if you prefer not to piece your backing, wide-width backing fabrics are available. Just be sure to recalculate the yardage needed. If you will be using a long-arm quilting service, be sure to check with the quilter because she may have her own specific preparation requirements.

1. Lay your backing fabric on a clean, flat surface, wrong side up. Smooth out any wrinkles. Use masking tape around the edges to secure it in place.

2. Lay the batting over the backing and smooth out any wrinkles.

3. Center the pressed quilt top over the batting. Smooth out any wrinkles and make sure the quilt top edges are parallel to the edges of the backing. Baste the layers together by using either a large basting stitch or rustproof safety pins.

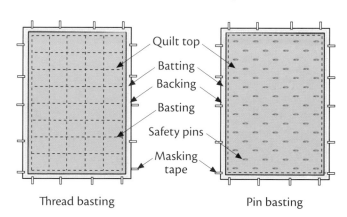

Quilt top
Batting
Backing
Basting
Safety pins
Masking tape

Thread basting Pin basting

Quilting

Many patterns will simply tell you to "quilt as desired." That doesn't really give you a lot of information, does it? The quilting design you choose is a matter of personal preference. In this book, I describe how I've quilted the samples to provide some guidance, but feel free to do your own thing. Some people like to stitch in the ditch, which is quilting in the seams. Some like to echo quilt, which is outlining the design. Still others trace designs from templates and quilt the marked lines. All these methods are used a lot in hand quilting and can also be used when machine quilting. I'm making another confession here: I do not hand quilt very well. I'm what you call a "stab stitcher," and I'm *very* slow. That's why the majority of my projects are quilted on the machine. I usually do an allover free-motion meandering design, throwing in a few stars and curlicues along the way. There are many great resources out there that teach quilting. As with anything, practice makes perfect.

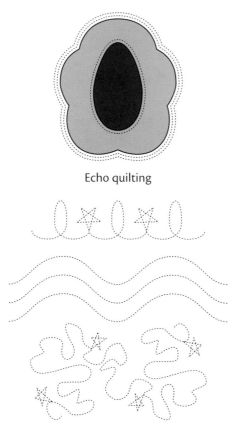

Echo quilting

Free-motion machine-quilting designs

Single-Fold Binding

I use a single-fold binding when a quilt will be handled or laundered rarely, such as with wall hangings and table runners.

1. Cut the strips the width indicated in the project instructions. Lay the strips perpendicular to each other and draw a line from the point where the strips meet at the lower left to where the strips meet at the upper right. Stitch on the drawn line. Trim ¼" from the stitching. Press the seam allowance to one side.

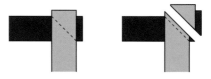

2. Trim the starting end of the binding at a 45° angle and press under a narrow hem to finish the raw edge.

3. With right sides together, lay the binding along one side of the quilt top, aligning one raw edge of the binding with the raw edge of the quilt. Pin the binding in place, placing the last pin ¼" from the corner. Stitch the binding in place, starting 2" from the end of the strip and ending at the last pin; backstitch. Remove the quilt from the machine.

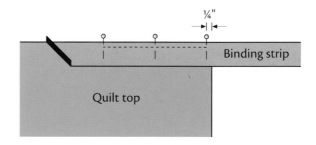

4. Rotate the quilt so you are ready to sew the next edge. Fold the binding up so that the fold makes a 45° angle, and then fold it back down onto itself

so the raw edges are aligned. Pin the binding in place as before, placing the last pin ¼" from the next corner. Begin stitching at the edge, backstitch, and then continue stitching until you reach the last pin; backstitch. Repeat to sew the remaining corners.

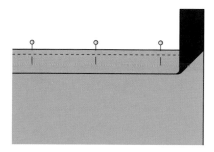

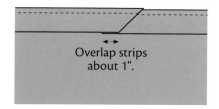

5. When you are close to the beginning of the binding, trim the end of the strip so it overlaps the beginning by about 1". Continue sewing the binding to the quilt.

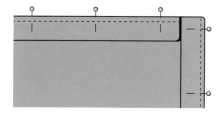

Overlap strips about 1".

6. Fold the binding to the back of the quilt. Fold under a small amount of the raw edge and hand blindstitch the folded edge in place with thread in a matching color, mitering the corners.

Double-Fold Binding

A double-fold binding is better for quilts that will be handled or laundered often, such as baby quilts or larger quilts and pillows. The strips I use are generally cut on the crosswise grain (width of fabric). Bias strips can be used but are not necessary for the straight edges of the projects in this book.

1. Refer to steps 1 and 2 of "Single-Fold Binding" to prepare the binding strip.

2. Press the strip in half lengthwise, wrong sides together.

Fold line

3. With raw edges aligned, pin the binding to the quilt top, placing the first pin 2" from the beginning of the strip and the last pin ¼" from the corner. Begin sewing at the first pin and end sewing at the last pin; backstitch. Remove the quilt from the machine.

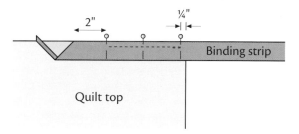

4. Refer to step 4 of "Single-Fold Binding" to stitch the remaining sides of the quilt.

5. When you are close to the beginning of the binding, trim the end of the strip so it overlaps the beginning about 1½". Tuck the end of the binding into the beginning of the binding and finish sewing the binding to the quilt.

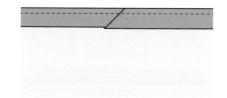

6. Fold the binding to the back of the quilt and hand blindstitch the folded edge in place with matching-colored thread, mitering the corners.

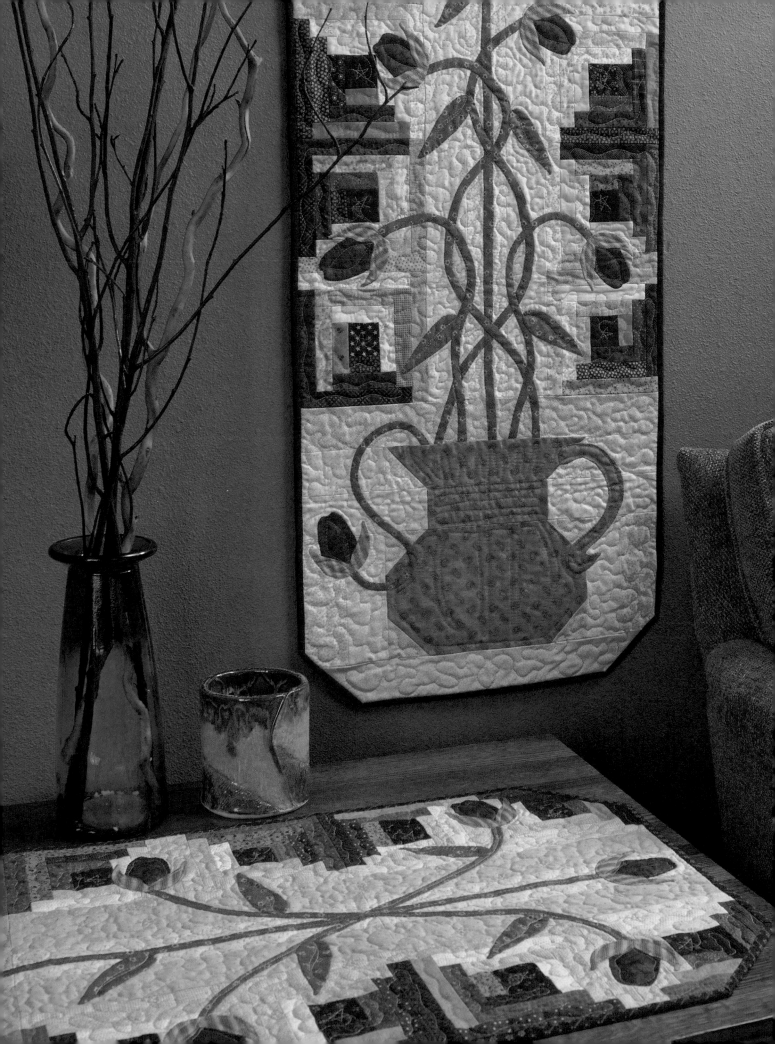

Blooms in the Cabin

Turn Log Cabin blocks into unique designs by adding lovely winding stems and flowers. The wall hanging and table runner will add country charm to any room in your home.

The Log Cabin Block

Log Cabin blocks are made up of dark and light strips that are positioned so that one half of the block is dark and the other half is light. These blocks can be laid out in many ways to create unique designs. The Log Cabin blocks for these projects begin with a center square that measures 2" unfinished, and dark and light strips that measure 1¼" wide unfinished. Cut the strips and squares as indicated for the project; then follow these instructions to piece each Log Cabin block:

1. Join the dark 1¼" x 2" log (B) to the left side of the 2" center square (A). Press the seam allowance open or away from the center square.

2. Add the dark 1¼" x 2¾" log (C) to the top of the AB unit. Press the seam allowance open or away from the center square. Continue adding the remaining logs clockwise around the block in alphabetical order. This keeps the darks and lights on opposite sides of the block, which creates the classic Log Cabin design. As you add each strip, press the seam allowances open or away from the center square.

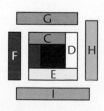
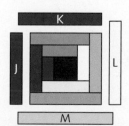
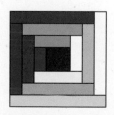

blooms in the cabin Wall Hanging

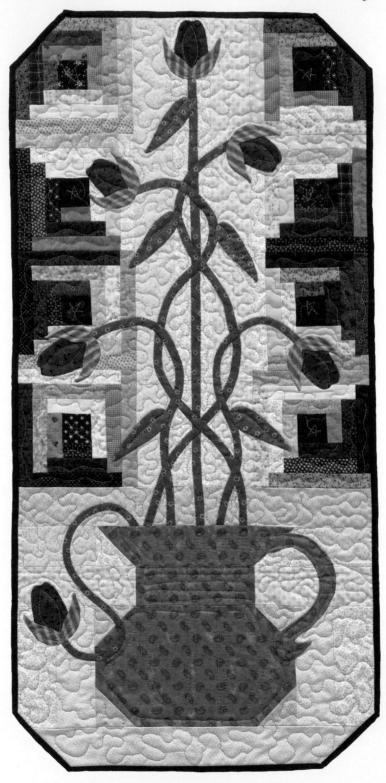

Finished Wall Hanging: 18½" x 38½"
Finished Block: 6" x 6"

Materials

Yardage is based on 42"-wide fabric.

6 fat eighths of assorted dark fabrics for blocks

6 fat eighths of assorted light fabrics for blocks

⅝ yard *total* of assorted light and medium tan fabrics for background

1 fat quarter of medium gold fabric for flowerpot

1 fat quarter of dark green fabric for stems and leaves

⅛ yard *total* of assorted burgundy fabrics for blocks

1 fat eighth of dark pink fabric for flowers

1 fat eighth of medium green fabric for calyxes

¼ yard of burgundy fabric for binding

1⅓ yards of fabric for backing

26" x 46" piece of batting

Cutting

Cut strips across the width of the fabric unless otherwise noted. Refer to "Making Bias Stems" on page 12 to cut bias strips. All measurements include ¼"-wide seam allowances.

From the assorted burgundy fabrics, cut:

• 8 squares, 2" x 2" (A)

From the fat eighths of assorted dark fabrics, cut:

• 8 rectangles, 1¼" x 5¾" (K)
• 8 rectangles, 1¼" x 5" (J)
• 8 rectangles, 1¼" x 4¼" (G)
• 8 rectangles, 1¼" x 3½" (F)
• 8 rectangles, 4" x 2¾" (C)
• 8 rectangles, 1¼" x 2" (B)

From the fat eighths of assorted light fabrics, cut:

• 8 rectangles, 1¼" x 6½" (M)
• 8 rectangles, 1¼" x 5¾" (L)
• 8 rectangles, 1¼" x 5" (I)
• 8 rectangles, 1¼" x 4¼" (H)
• 8 rectangles, 1¼" x 3½" (E)
• 8 rectangles, 1¼" x 2¾" (D)

From the assorted light and medium tan fabrics, cut:

• 3 strips, 2½" x 24½"
• 2 strips, 2½" x 18½"
• 6 rectangles, 2½" x 6½"
• 2 rectangles, 2½" x 4½"
• 6 squares, 2½" x 2½"

From the medium gold fat quarter, cut:

• 1 rectangle, 6½" x 10½"
• 1 strip, 2½" x 10½"
• 1 rectangle, 2½" x 6½"
• Reserve the remainder of the fat quarter for pot-handle appliqué.

From the dark green fat quarter, cut:

• 3 bias strips, 1" x 22"
• 2 bias strips, 1" x 18"
• 1 bias strip, 1" x 14"
• Reserve the remainder of the fat quarter for leaf appliqués.

From the burgundy fabric for binding, cut:

• 3 strips, 1½" x 42", for single-fold binding. If you prefer double-fold binding, cut strips at least 2" wide.

Making the Log-Cabin Unit

1. Refer to "The Log Cabin Block" on page 17 to make eight Log Cabin blocks using the A–M pieces.

2. Lay out four blocks, rotating them so that the dark and light halves are positioned as shown. Sew the blocks together to form one vertical row. Repeat to make a second row. Press the seam allowances open.

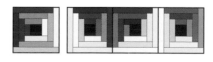

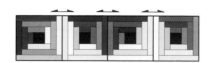

Make 2.

3. Sew the three tan 2½" x 24½" strips together along the long edges. Press the seam allowances toward the outer strips.

4. Sew the light sides of the log-cabin units to the sides of the tan unit. Press the seam allowances toward the tan unit.

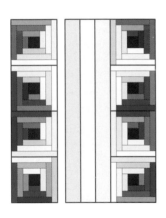

5. Sew a tan 2½" x 18½" strip to the bottom of the log-cabin unit. Press the seam allowance toward the tan strip.

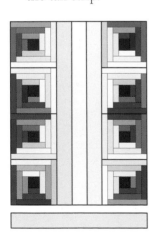

Making the Pot Unit

1. Refer to the "Folded-Corner Technique" on page 10 to sew two tan 2½" squares to the gold 2½" x 10½" rectangle and four tan 2½" squares to the gold 6½" x 10½" rectangle.

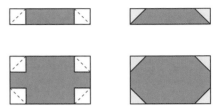

2. Sew two tan 2½" x 6½" rectangles together. Repeat to make one additional unit. Press the seam allowances in either direction. Sew these units to opposite sides of the 6½" x 10½" rectangle from step 1. Press the seam allowances toward the strip units.

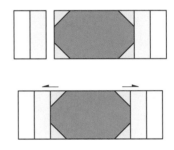

3. Sew tan 2½" x 6½" rectangles to opposite ends of the gold 2½" x 6½" rectangle. Press the seam allowances toward the gold rectangle. Sew this unit to the top of the unit from step 2.

4. Sew tan 2½" x 4½" rectangles to opposite ends of the remaining unit from step 1. Join this unit to the top of the pot unit from step 3. Sew the remaining tan 2½" x 18½" strip to the bottom of

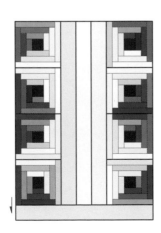

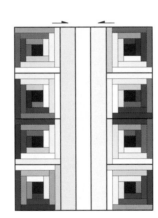

the unit to complete the pot. *Do not join the log cabin and pot units yet.*

Appliquéing and Assembling the Units

Use your preferred method of appliqué or refer to "Appliqué" on page 11 for more information on needle-turn hand appliqué and fusible-web machine appliqué. Refer to the diagram at right for appliqué placement.

1. Using patterns 1–4 on page 25 and your preferred appliqué method, make the appliqué shapes from the fabrics indicated.

2. Appliqué the pot handle to the pot unit.

3. Refer to "Making Bias Stems" on page 12 to make stems from the dark green bias strips. Appliqué the 22"-long straight center stem to the log-cabin unit first, and then the two 18"-long curved stems on each side of it, followed by the two 14"-long curved stems. The final stem will be partially appliquéd to the log-cabin unit and completed once the log-cabin and pot units are joined. Start by appliquéing the end of the stem to the log-cabin unit, curving it down toward where the pot unit will be. Stop stitching before you reach the seam allowance. This will hold the stem in place until the two units are joined.

4. Join the pot unit to the bottom of the log cabin unit, and then finish appliquéing the loose stem to the pot unit.

5. Appliqué the flowers, calyxes, and leaves in place, working in numerical order.

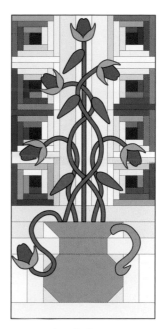

Appliqué placement

6. Trim all four corners of the quilt top at a 45° angle. You can do this by measuring 2" in and down from each corner and making a mark. Use your rotary cutter and ruler to cut diagonally from mark to mark in each corner.

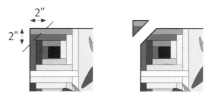

Finishing the Wall Hanging

Refer to "Finishing Techniques" on page 13 for instructions as needed.

1. Layer the wall hanging top with batting and backing; baste.

2. Quilt as desired. I machine quilted my wall hanging with an overall meandering stitch. I also echo quilted inside the stems, flowers, and leaves to make them stand out.

3. Use the burgundy strips to bind the quilt.

blooms in the cabin Table Runner

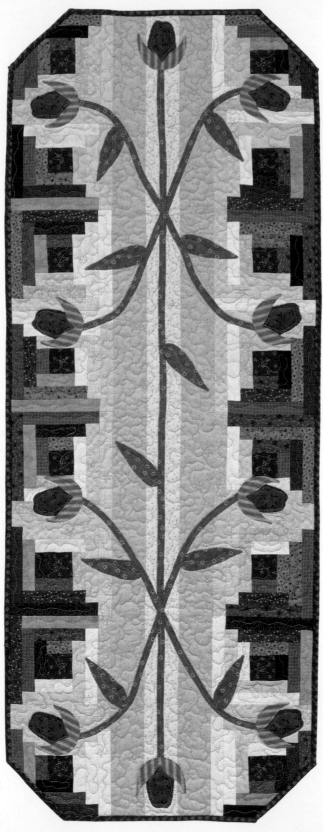

Finished Table Runner:
18½" x 48½"

Finished Block: 6" x 6"

Materials

Yardage is based on 42"-wide fabric.

6 fat quarters of assorted dark fabrics for blocks

6 fat quarters of assorted light fabrics for blocks

⅓ yard of medium tan fabric for background

¼ yard of light tan fabric for background

1 fat quarter of dark green fabric for stems and leaves

1 fat eighth of burgundy fabric for blocks

1 fat eighth of dark pink fabric for flowers

1 fat eighth of medium green fabric for calyxes

⅓ yard of dark red fabric for binding

1⅝ yards of fabric for backing

26" x 56" piece of batting

Cutting

Cut strips across the width of the fabric unless otherwise noted. Refer to "Making Bias Stems" on page 12 to cut bias strips. All measurements include ¼"-wide seam allowances.

From the fat eighth of burgundy fabric, cut:

- 16 squares, 2" x 2" (A)

From the fat quarters of assorted dark fabrics, cut:

- 16 rectangles, 1¼" x 5¾" (K)
- 16 rectangles, 1¼" x 5" (J)
- 16 rectangles, 1¼" x 4¼" (G)
- 16 rectangles, 1¼" x 3½" (F)
- 16 rectangles, 1¼" x 2¾" (C)
- 16 rectangles, 1¼" x 2" (B)

From the fat quarters of assorted light fabrics, cut:

- 16 rectangles, 1¼" x 6½" (M)
- 16 rectangles, 1¼" x 5¾" (L)
- 16 rectangles, 1¼" x 5" (I)
- 16 rectangles, 1¼" x 4¼" (H)
- 16 rectangles, 1¼" x 3½" (E)
- 16 rectangles, 1¼" x 2¾" (D)

From the light tan fabric, cut:

- 4 strips, 2½" x 12½"

From the medium tan fabric, cut:

- 8 strips, 2½" x 12½"

From the dark green fat quarter, cut:

- 6 bias strips, 1" x 22"
- Reserve the remainder of the fat quarter for leaf appliqués.

From the dark red fabric, cut:

- 4 strips, 1½" x 42", for single-fold binding. If you prefer double-fold binding, cut strips at least 2" wide.

Assembling the Table Runner Top

1. Refer to "The Log Cabin Block" on page 17 to make 16 Log Cabin blocks using the A–M pieces.

2. Lay out eight blocks, rotating them so that the dark and light halves are positioned as shown. Sew the blocks together to form one horizontal row. Repeat to make a second row. Press the seam allowances open.

Make 2.

3. Join the four light tan 2½" x 12½" strips into one long strip. Press the seam allowances in one direction. Sew four medium tan 2½" x 12½" strips into one long strip. Repeat to make a second medium tan strip. Press the seam allowances in the opposite direction as the light tan strip. Sew the medium tan strips to the long edges of the light tan strip.

Press the seam allowances toward the medium tan strips.

4. Join the light side of the log-cabin rows from step 2 to the long sides of the unit from step 3. Press the seam allowances toward the medium tan strips.

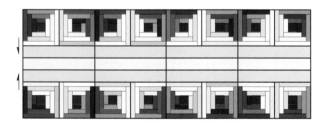

Appliquéing the Table Runner

Use your preferred method of appliqué or refer to "Appliqué" on page 11 for more information on needle-turn hand appliqué and fusible-web machine appliqué. Refer to the diagram above right for appliqué placement.

1. Join two of the dark green bias strips to make one long strip approximately 43½" long. You will now have four 22"-long bias strips and one 43½"-long bias strip.

2. Refer to "Making Bias Stems" on page 12 to make stems from the bias strips.

3. Appliqué two short stems on one half of the table-runner top to create an X. Repeat on the opposite half. Appliqué the long stem through the center of the table runner.

4. Using patterns 2, 3, and 4 on page 25 and your preferred appliqué method, make the appliqué shapes from the fabrics indicated.

5. Appliqué the flowers, calyxes, and leaves in place, working in numerical order.

6. Trim the corners of the table runner at a 45° angle. You can do this by measuring 2" in and down from each corner and making a mark. Use your rotary cutter and ruler to cut diagonally from mark to mark in each corner.

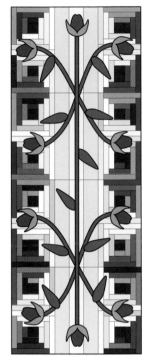

Appliqué placement

Finishing the Table Runner

Refer to "Finishing Techniques" on page 13 for instructions as needed.

1. Layer the table-runner top with batting and backing; baste.

2. Quilt as desired. I machine quilted my table runner with an overall meandering stitch. I also echo quilted inside the stems, flowers, and leaves to make them stand out.

3. Use the dark red strips to bind the quilt.

Patterns do not include
seam allowances.

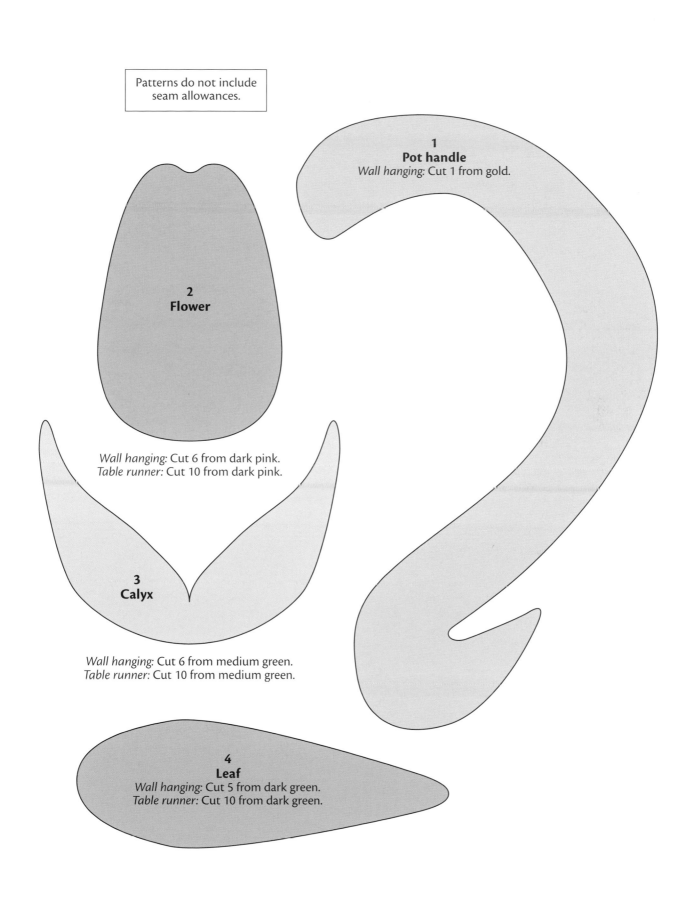

1
Pot handle
Wall hanging: Cut 1 from gold.

2
Flower

Wall hanging: Cut 6 from dark pink.
Table runner: Cut 10 from dark pink.

3
Calyx

Wall hanging: Cut 6 from medium green.
Table runner: Cut 10 from medium green.

4
Leaf
Wall hanging: Cut 5 from dark green.
Table runner: Cut 10 from dark green.

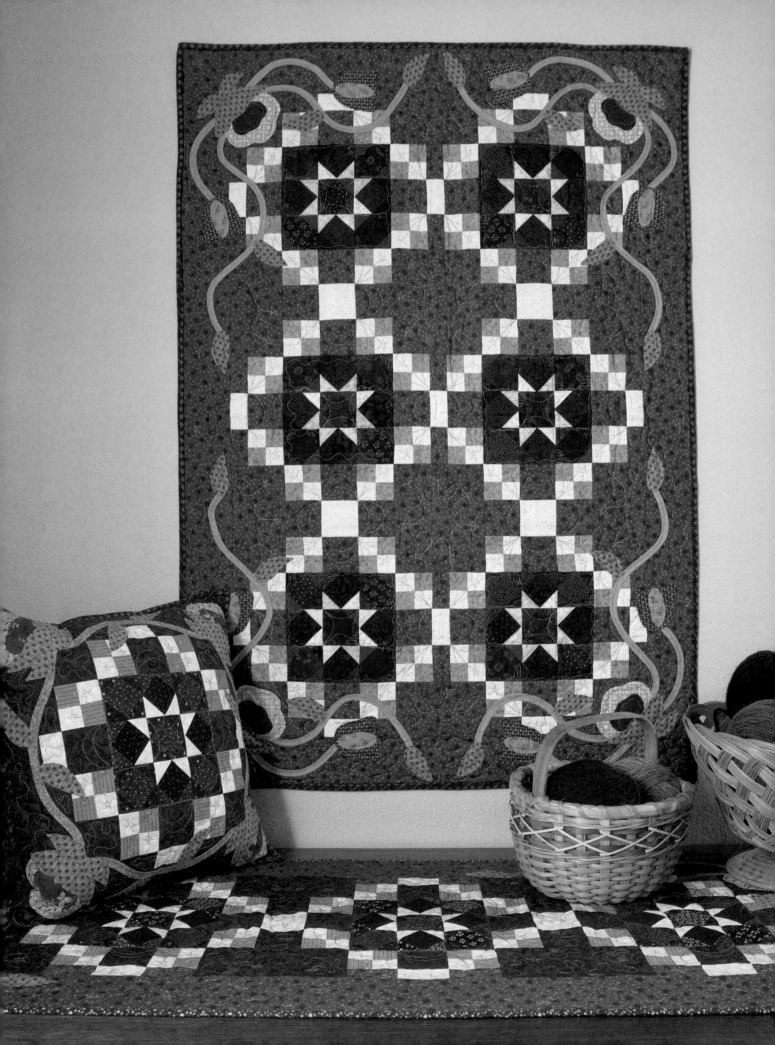

Star Garden

In this grouping, square-in-a-square units are arranged to create a star pattern in each Star Garden block. Blue-and-white alternate blocks are set around each of these blocks to make them stand out. The pieced units are then surrounded by appliqués of winding vines and colorful flowers so you can enjoy a garden atmosphere throughout the year.

The Star Garden Block

Star Garden blocks are made up of nine square-in-a-square units. Each square-in-a-square unit is made using the "Folded-Corner Technique" described on page 10. The center of each unit will be either a dark red or black 2½" square. The corners are created with dark blue, dark red, or light tan 1½" squares.

1. Fold each dark red, dark blue, and light tan 1½" square in half or draw a diagonal line from corner to corner on the wrong side of each square.

2. Lay a dark blue 1½" square on the upper-right corner of a dark red 2½" square as shown, right sides together. Sew on the drawn line. Trim ¼" from the sewn line. Press the seam allowance open. Repeat on the opposite corner of the red square.

3. Repeat step 2, adding dark blue 1½" squares to the remaining two corners of the red square to create the square-in-a-square design. These squares are the center/corner units.

4. Repeat steps 2 and 3 with the black 2½" square and the light tan and red 1½" squares, positioning the colors as shown. These squares are the star units.

5. Trim the units ¼" from the points of the center square so that all of the units measure 2½".

6. To make one block, arrange five center/corner units and four star units into three horizontal rows as shown. Join the units in each row. Press the seam allowances open. Join the rows. Press the seam allowances open.

 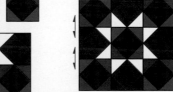

The Setting Blocks

There are three different setting blocks that create the pattern around the Star Garden blocks. These blocks are created from the medium blue, light tan, and dark blue or very dark blue background fabrics. The different setting blocks will be labeled A, B, and C. You will start by making the four-patch units, which are part of each of the different blocks.

1. Join a light tan 1½"-wide strip to a medium blue 1½"-wide strip along the long edges to make a strip set. Press the seam allowances toward the medium blue strip. Crosscut the strip set into the required amount of 1½"-wide segments.

2. Join two segments as shown to make a four-patch unit.

3. To make one block A, sew four-patch units to opposite sides of a dark blue or very dark blue 2½" square as shown. Be sure the four-patch units are positioned correctly. Make two of these units. Press the seam allowances toward the square.

Make 2.

4. Sew dark blue or very dark blue 2½" squares to opposite sides of a light tan 2½" square. Press the seam allowances toward the blue squares.

5. Lay out the step 3 and 4 units as shown. Be sure the four-patch units are positioned so the light squares run diagonally from corner to corner. Sew the units together. Press the seam allowances toward the center unit.

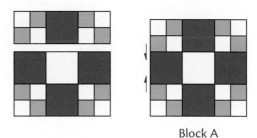

Block A

6. To make one block B, join dark blue 1½" x 2½" rectangles to opposite sides of a light tan 1½" x 2½" rectangle. Press the seam allowances toward the dark blue rectangles.

7. Join four-patch units to opposite sides of a dark blue or very dark blue 2½" square. Be sure the four-patch units are positioned correctly. Press the seam allowances toward the square.

8. Join the unit from step 6 to the top of the unit from step 7. Be sure the four-patch units are arranged so the upper dark squares are on the outside of the block.

Block B

9. To make one block C, sew four-patch units to opposite sides of a dark blue 1½" x 2½" rectangle. Be sure the four-patch units are positioned correctly. Make two of these units. Press the seam allowances toward the rectangles.

Make 2.

10. Join dark blue 2½" squares to opposite sides of a light tan 1½" x 2½" rectangle. Press the seam allowances toward the squares.

11. Lay out the step 9 and 10 units as shown. Be sure the four-patch units are arranged so the light squares run diagonally from corner to corner. Sew the units together. Press the seam allowances toward the center unit.

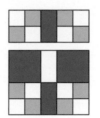

Block C

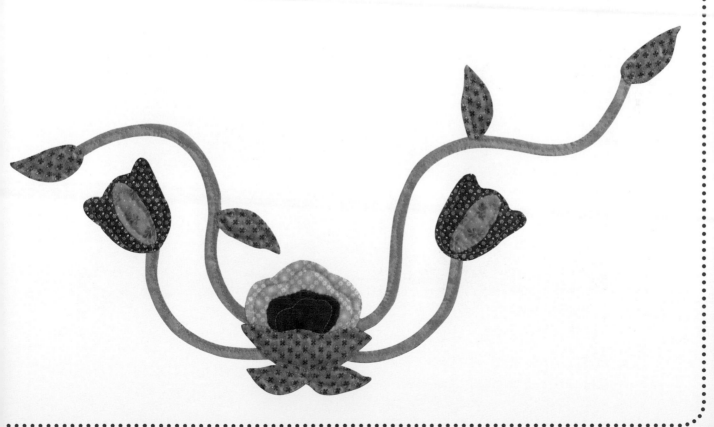

star garden Wall Hanging

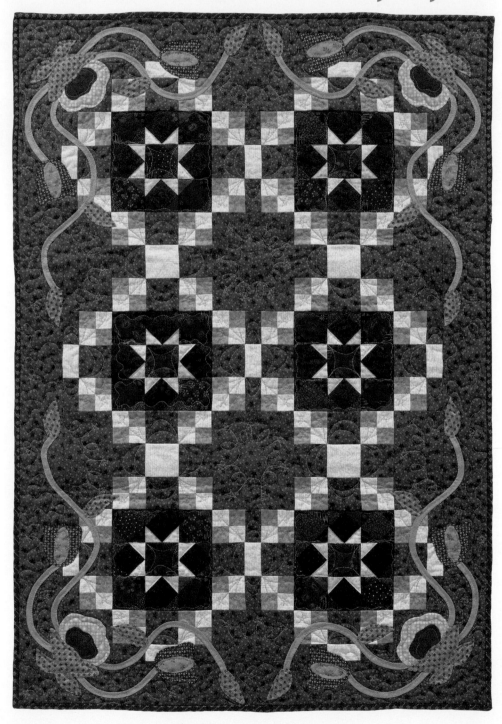

Finished Wall Hanging: 29" x 42"
Finished Star Garden Block: 6" x 6"
Finished Setting Block A: 6" x 6"
Finished Setting Block B: 6" x 3"
Finished Setting Block C: 5" x 6"

Materials

Yardage is based on 42"-wide fabric.

1⅛ yards of dark blue fabric for background

½ yard of light tan fabric for Star Garden and setting blocks

4 fat eighths of assorted dark blue fabrics for Star Garden blocks

4 fat eighths of assorted dark red fabrics for Star Garden blocks

¼ yard of medium blue fabric for setting blocks

¼ yard of black fabric for Star Garden blocks

1 fat quarter of medium green fabric #1 for stems

1 fat quarter of medium green fabric #2 for leaves and calyxes

1 fat eighth of medium red fabric for small flowers

9" x 9" square of medium gold fabric for large flowers

7" x 10" rectangle of dark gold fabric for small flower centers

6" x 6" piece of dark red fabric #1 for large flower centers

⅓ yard of dark red fabric #2 for binding

1½ yards of fabric for backing

37" x 50" piece of batting

Cutting

Cut strips across the width of the fabric unless otherwise noted. Refer to "Making Bias Stems" on page 12 to cut bias strips. All measurements include ¼"-wide seam allowances.

From the 4 fat eighths of assorted dark red fabrics, cut:

• 30 squares, 2½" x 2½"
• 48 squares, 1½" x 1½"

From the black fabric, cut:

• 24 squares, 2½" x 2½"

From the 4 fat eighths of assorted dark blue fabrics, cut:

• 120 squares, 1½" x 1½"

From the light tan fabric, cut:

• 4 strips, 1½" x 42"
• 4 squares, 2½" x 2½"
• 13 rectangles, 1½" x 2½"
• 48 squares, 1½" x 1½"

From the dark blue fabric for background, cut:

• 2 rectangles, 5½" x 6½"
• 4 rectangles, 3½" x 6½"
• 2 rectangles, 3½" x 5½"
• 4 squares, 3½" x 3½"
• 2 strips, 3¼" x 36½"
• 2 strips, 3¼" x 29"
• 32 squares, 2½" x 2½"
• 26 rectangles, 1½" x 2½"

From the medium blue fabric, cut:

• 4 strips, 1½" x 42"

From the fat quarter of medium green fabric #1, cut:

• 4 bias strips, 1" x 15"
• 4 bias strips, 1" x 12"
• 8 bias strips, 1" x 8"

From the dark red fabric #2, cut:

• 4 strips, 1½" x 42", for single-fold binding. If you prefer double-fold binding, cut the strips at least 2" wide.

Making the Blocks

1. Refer to "The Star Garden Block" on page 27 to make six Star Garden blocks using the assorted dark red and black 2½" squares and the assorted dark red, assorted dark blue, and light tan 1½" squares.

2. To make the setting blocks, refer to steps 1 and 2 of "The Setting Blocks" on page 28 to make four strip sets from the light tan and medium blue 1½" x 42" strips. Crosscut the strip sets into 96 segments. Make 48 four-patch units from the segments.

3. Refer to steps 3–5 of "The Setting Blocks" to make four of setting block A using 16 four-patch units, 16 dark blue 2½" squares, and four light tan 2½" squares.

4. Refer to steps 6–8 of "The Setting Blocks" to make 10 of setting block B using 20 four-patch units, 20 dark blue 1½" x 2½" rectangles, 10 light tan 1½" x 2½" rectangles, and 10 dark blue 2½" squares.

5. Refer to steps 9–11 of "The Setting Blocks" to make three of setting block C using 12 four-patch units, 6 dark blue 2½" squares, 6 dark blue 1½" x 2½" rectangles, and 3 light tan 1½" x 2½" rectangles.

Assembling the Wall Hanging Top

1. Join B blocks to opposite sides of a dark blue 3½" x 5½" rectangle. Press the seam allowances toward the dark blue rectangle. Add dark blue 3½" squares to both ends of this unit. Press the seam allowances toward the squares. Repeat to make a total of two rows.

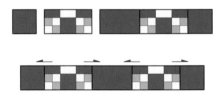

Make 2.

2. Join Star Garden blocks to opposite sides of a C block. Press the seam allowances toward the Star Garden blocks. Add B blocks to both ends of this unit. Press the seam allowances toward the Star Garden blocks. Repeat to make a total of three rows.

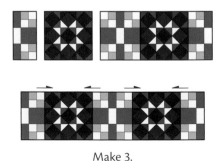

Make 3.

3. Join A blocks to the sides of a dark blue 5½" x 6½" rectangle. Press the seam allowances toward the rectangle. Add dark blue 3½" x 6½" rectangles to both ends of this unit. Press the seam allowances toward the rectangles. Repeat to make a total of two rows.

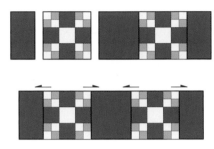

Make 2.

4. Lay out the rows as shown. Sew the rows together. Press the seam allowances in whichever direction creates the least amount of bulk.

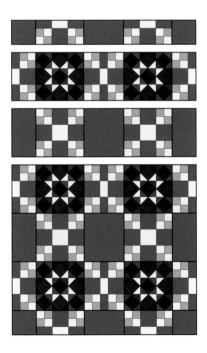

5. Join the dark blue 3¼" x 36½" border strips to the sides of the quilt top. Press the seam allowances toward the strips. Join the dark blue 3¼" x 29" strips to the top and bottom edges of the quilt top. Press the seam allowances toward the strips.

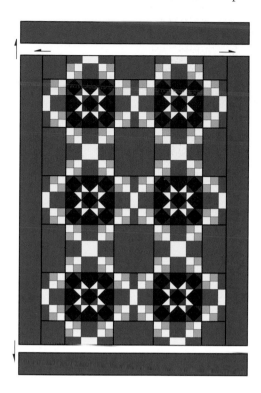

3. Appliqué the shapes in place, working in numerical order.

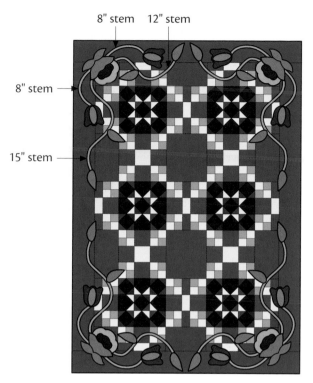

Appliqué placement

Adding the Appliqués

Use your preferred method of appliqué or refer to "Appliqué" on page 11 for more information on needle-turn hand appliqué and fusible-web machine appliqué. Refer to the diagram at right for appliqué placement.

1. Refer to "Making Bias Stems" on page 12 to make stems from the bias strips. Appliqué the stems to the wall hanging top. The flower and leaf appliqués will cover the stem raw ends.

2. Using the patterns on pages 42 and 43 and your preferred appliqué method, make the appliqué shapes from the fabrics indicated.

Finishing the Wall Hanging

Refer to "Finishing Techniques" on page 13 for instructions as needed.

1. Layer the wall hanging top with batting and backing; baste.

2. Quilt as desired. I machine quilted my wall hanging with a free-motion design of loops and stars. I also echo quilted inside the Star Garden blocks, stems, flowers, and leaves to make them stand out.

3. Use the dark red #2 strips to bind the wall hanging.

star garden Table Runner

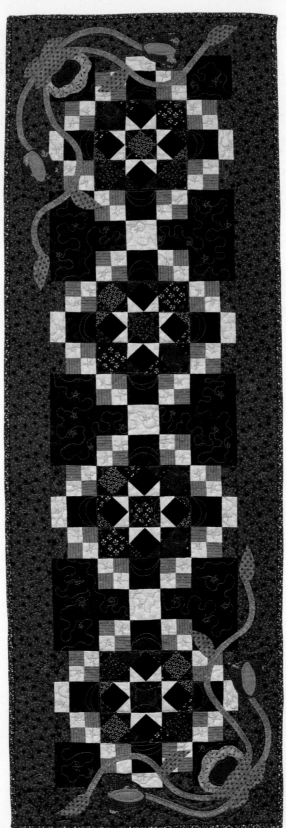

Finished Table Runner:
18" x 54"
Finished Star Garden Block:
6" x 6"
Finished Setting Block A: 6" x 6"
Finished Setting Block B: 6" x 3"

Materials

Yardage is based on 42"-wide fabric.

⅝ yard of dark blue fabric for background

½ yard of very dark blue fabric for background

4 fat eighths of assorted dark blue fabrics for Star Garden blocks

4 fat eighths of assorted dark red fabrics for Star Garden blocks

⅜ yard of light tan fabric for Star Garden blocks and setting blocks

¼ yard of medium blue fabric for setting blocks

1 fat eighth of black fabric for Star Garden blocks

1 fat eighth of medium green fabric #1 for stems

1 fat eighth of medium green fabric #2 for calyxes and leaves

7" x 7" scrap of medium red fabric for small flowers

5" x 8" scrap of medium gold fabric for large flowers

4" x 6" scrap of dark gold fabric for small flower centers

3" x 5" scrap of dark red fabric #1 for large flower centers

⅓ yard of dark red fabric #2 for binding

1⅞ yards of fabric for backing

26" x 62" piece of batting

Cutting

Cut strips across the width of the fabric unless otherwise noted. Refer to "Making Bias Stems" on page 12 to cut bias strips. All measurements include ¼"-wide seam allowances.

From the fat eighths of assorted dark red fabrics, cut:

- 20 squares, 2½" x 2½"
- 32 squares, 1½" x 1½"

From the black fabric, cut:

- 16 squares, 2½" x 2½"

From the fat eighths of assorted dark blue fabrics, cut:

- 80 squares, 1½" x 1½"

From the light tan fabric, cut:

- 3 strips, 1½" x 42"
- 3 squares, 2½" x 2½"
- 10 rectangles, 1½" x 2½"
- 32 squares, 1½" x 1½"

From the medium blue fabric, cut:

- 3 strips, 1½" x 42"

From the very dark blue fabric, cut:

- 6 rectangles, 3½" x 6½"
- 4 squares, 3½" x 3½"
- 22 squares, 2½" x 2½"

From the dark blue fabric, cut:

- 4 strips, 3¼" x 24½"
- 2 strips, 3¼" x 18"
- 20 rectangles, 1½" x 2½"

From the fat eighth of medium green fabric #1, cut:

- 2 bias strips, 1" x 15"
- 2 bias strips, 1" x 12"
- 4 bias strips, 1" x 8"

From the dark red fabric #2, cut:

- 4 strips, 1½" x 42", for single-fold binding. If you prefer double-fold binding, cut strips at least 2" wide.

Making the Blocks

1. Refer to "The Star Garden Block" on page 27 to make four Star Garden blocks using the assorted dark red and black 2½" squares and the assorted dark red, assorted dark blue, and light tan 1½" squares.

2. To make the setting blocks, refer to steps 1 and 2 of "The Setting Blocks" on page 28 to make three strip sets from the light tan and medium blue 1½" x 42" strips. Crosscut the strip sets into 64 segments. Make 32 four-patch units from the segments.

3. Refer to steps 3–5 of "The Setting Blocks" to make three of setting block A using 12 four-patch units, 12 very dark blue 2½" squares, and three light tan 2½" squares.

Make 3.

4. Refer to steps 6–8 of "The Setting Blocks" to make 10 of setting block B using 20 four-patch units, 20 dark blue 1½" x 2½" rectangles, 10 light tan 1½" x 2½" rectangles, and 10 very dark blue 2½" squares.

Make 10.

Assembling the Table Runner Top

1. Join very dark blue 3½" squares to opposite sides of a B block. Press the seam allowances toward the squares. Repeat to make a total of two rows.

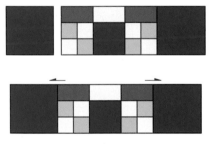

Make 2.

2. Join B blocks to opposite sides of a Star Garden block. Press the seam allowances toward the Star Garden block. Repeat to make a total of four rows.

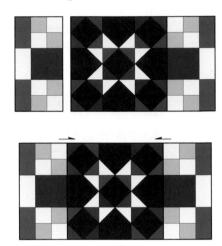

Make 4.

3. Join very dark blue 3½" x 6½" rectangles to opposite sides of an A block. Press the seam allowances toward the rectangles. Repeat to make a total of three rows.

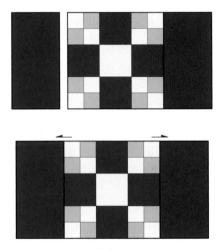

Make 3.

4. Lay out the rows as shown. Sew the rows together. Press the seam allowances in whichever direction creates the least amount of bulk.

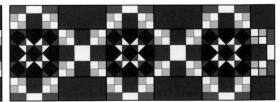

5. Join two dark blue 3¼" x 24½" strips along the short ends to make one long strip. Repeat to make a total of two strips. Sew these strips to the sides of the table runner. Press the seam allowances toward the strips. Sew the dark blue 3¼" x 18" strips to the top and bottom of the table runner. Press the seam allowances toward the strips.

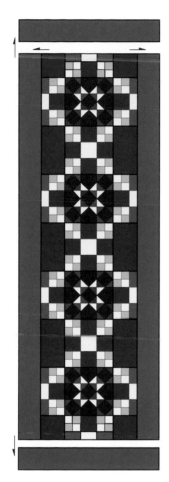

2. Using the patterns on pages 42 and 43 and your preferred appliqué method, make the appliqué shapes from the fabrics indicated.

3. Appliqué the shapes in place, working in numerical order.

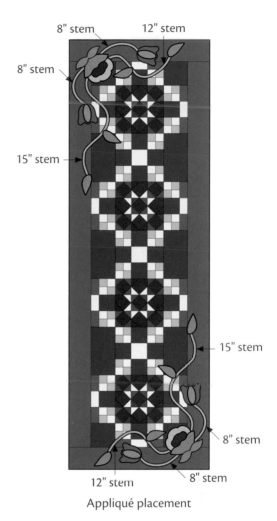

Appliqué placement

Adding the Appliqués

Use your preferred method of appliqué or refer to "Appliqué" on page 11 for more information on needle-turn hand appliqué and fusible-web machine appliqué. Refer to the diagram at right for appliqué placement.

1. Refer to "Making Bias Stems" on page 12 to make stems from the bias strips. Appliqué the stems to the quilt top. The flower and leaf appliqués will cover the stem raw ends.

Finishing the Table Runner

Refer to "Finishing Techniques" on page 13 for instructions as needed.

1. Layer the table-runner top with batting and backing; baste.

2. Quilt as desired. I machine quilted my table runner with a free-motion design of loops and stars. I also echo quilted inside the Star Garden blocks, stems, flowers, and leaves to make them stand out.

3. Use the dark red #2 strips to bind the table runner.

star garden Pillow

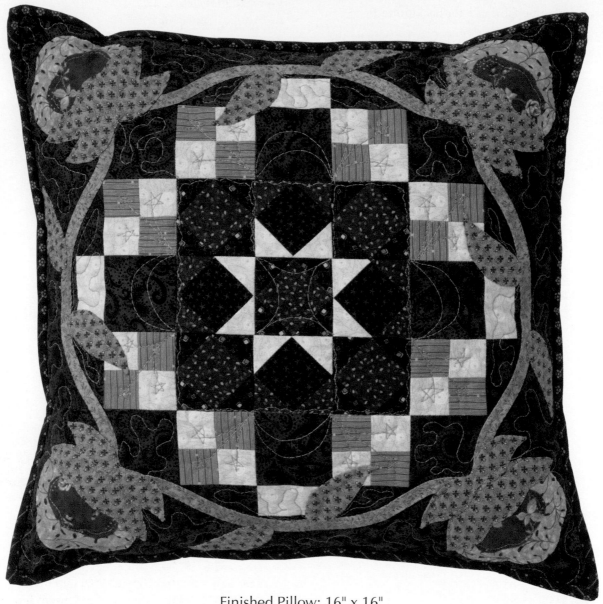

Finished Pillow: 16" x 16"
Finished Star Garden Block: 6" x 6"
Finished Setting Block B: 6" x 3"

Materials

Yardage is based on 42"-wide fabric.

⅜ yard of dark blue fabric #1 for background

¼ yard of light tan fabric for Star Garden blocks and setting blocks

⅛ yard of medium blue fabric for setting blocks

1 fat eighth of dark blue fabric #2 for Star Garden block

1 fat eighth of black fabric for Star Garden block

1 fat eighth of dark red fabric #1 for Star Garden block

1 fat eighth of medium green fabric #1 for stems

1 fat eighth of medium green fabric #2 for calyxes and leaves

1 fat eighth of medium gold fabric for flowers

4" x 6" scrap of dark red fabric #2 for flower centers

¼ yard of dark red fabric #3 for binding

1 fat quarter of fabric for pillow backing

16½" x 16½" square of dark blue fabric for pillow back

20" x 20" square of batting

16" x 16" square pillow form

Cutting

Cut strips across the width of the fabric unless otherwise noted. Refer to "Making Bias Stems" on page 12 to cut bias strips. All measurements include ¼"-wide seam allowances.

From the fat eighth of dark red fabric #1, cut:

- 5 squares, 2½" x 2½"
- 8 squares, 1½" x 1½"

From the fat eighth of black fabric, cut:

- 4 squares, 2½" x 2½"

From the fat eighth of dark blue fabric #2, cut:

- 20 squares, 1½" x 1½"

From the light tan fabric, cut:

- 1 strip, 1½" x 42"
- 4 rectangles, 1½" x 2½"
- 8 squares, 1½" x 1½"

From the medium blue fabric, cut:

- 1 strip, 1½" x 42"

From the dark blue fabric #1, cut:

- 4 squares, 3½" x 3½"
- 4 squares, 2½" x 2½"
- 8 rectangles, 1½" x 2½"
- 2 strips, 2½" x 16½"
- 2 strips, 2½" x 12½"

From the fat eighth of medium green fabric #1, cut:

- 4 bias strips, 1" x 10"

From the dark red fabric #3, cut:

- 2 strips, 1½" x 42", for single-fold binding. If you prefer double-fold binding, cut strips at least 2" wide.

Making the Blocks

1. Refer to "The Star Garden Block" on page 27 to make one Star Garden block using the dark red and black 2½" squares and the dark red, dark blue #2, and light tan 1½" squares.

2. To make the setting blocks, refer to steps 1 and 2 of "The Setting Blocks" on page 28 to make one strip set from the light tan and medium blue 1½" x 42" strips. Crosscut the strip set into 16 segments. Make eight four-patch units from the segments.

3. Refer to steps 6–8 of "The Setting Blocks" to make four of setting block B using the four-patch units, the dark blue #1 and light tan 1½" x 2½" rectangles, and the 2½" dark blue #1 squares.

Assembling the Pillow Top

1. Join 3½" dark blue #1 squares to opposite sides of a B block. Press the seam allowances toward the squares. Repeat to make two rows.

Make 2.

2. Join a B block to opposite sides of the Star Garden block. Press the seam allowances toward the Star Garden block.

Make 1.

3. Lay out the step 1 and 2 rows as shown. Sew the rows together. Press the seam allowances in whichever direction creates the least amount of bulk.

4. Join the 2½" x 12½" dark blue #1 strips to the sides of the pillow top. Press the seam allowances toward the strips. Join the 2½" x 16½" dark blue #1 strips to the top and bottom of the pillow top. Press the seam allowances toward the strips.

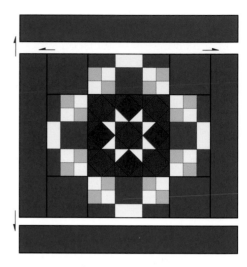

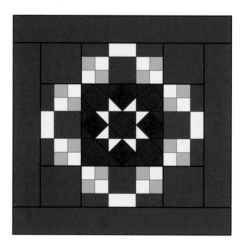

Adding the Appliqués

Use your preferred method of appliqué or refer to "Appliqué" on page 11 for more information on needle-turn hand appliqué and fusible-web machine appliqué. Refer to the diagram below for appliqué placement.

1. Refer to "Making Bias Stems" on page 12 to make stems from the bias strips. Appliqué the stems to the quilt top. The flower and leaf appliqués will cover the stem raw ends.

2. Using the patterns on pages 42 and 43 and your preferred appliqué method, make the appliqué shapes from the fabrics indicated.

3. Appliqué the shapes in place, working in numerical order.

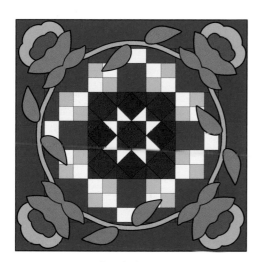

Appliqué placement

Finishing the Pillow

Refer to "Finishing Techniques" on page 13 for instructions as needed.

1. Layer the pillow top with the batting and backing; baste.

2. Quilt as desired. I machine quilted curlicues and stars in the Star Garden block and other areas. I echo quilted the stems, leaves, and flowers to make them stand out. Trim the excess batting and backing even with the pillow top when the quilting is completed.

3. Lay the pillow top and back right sides together. Using a ⅛" seam allowance, stitch along *three* sides only. Leave the remaining side open for turning.

Leave this side open.

4. Turn the pillow right side out and insert the pillow form. Sew the opening closed by hand or machine. The binding will cover the stitches.

5. Use the dark red #3 strips to bind the pillow edges.

Patterns do not include seam allowances.

1
Large flower
Wall hanging: Cut 4 from medium gold.
Table runner: Cut 2 from medium gold.
Pillow: Cut 4 from medium gold.

2
Large flower center
Wall hanging: Cut 4 from dark red #1.
Table runner: Cut 2 from dark red #1.
Pillow: Cut 4 from dark red #2.

3
Calyx
Wall hanging: Cut 4 from medium green #2.
Table runner: Cut 2 from medium green #2.
Pillow: Cut 4 from medium green #2.

4
Large leaf

Wall hanging: Cut 4 from medium green #2.
Table runner: Cut 2 from medium green #2.
Pillow: Cut 4 from medium green #2.

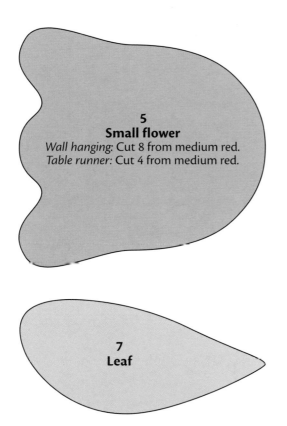

Patterns do not include
seam allowances.

5
Small flower
Wall hanging: Cut 8 from medium red.
Table runner: Cut 4 from medium red.

6
**Small flower
center**

7
Leaf

Wall hanging: Cut 8 from dark gold.
Table runner: Cut 4 from dark gold.

Wall hanging: Cut 8 and 8 reversed from medium green #2.
Table runner: Cut 4 and 4 reversed from medium green #2.
Pillow: Cut 8 from medium green #2.

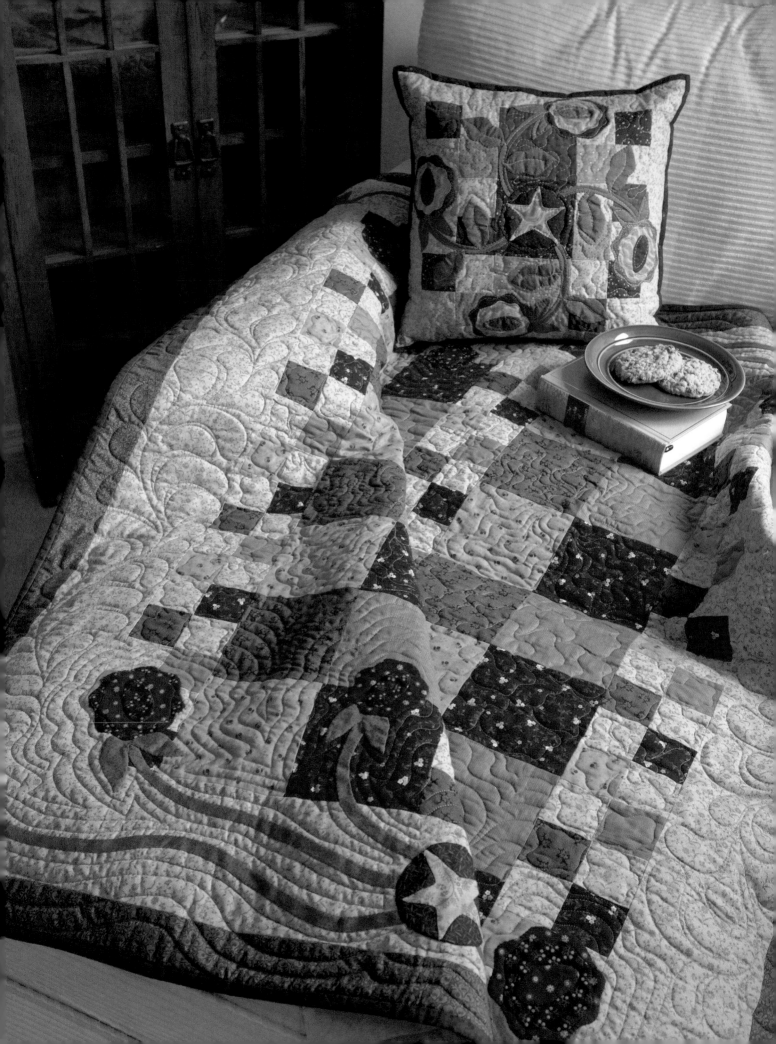

Patchwork Blooms

Large and small Four Patch blocks create a colorful background for a garden of blooms. The lap quilt and pillow are cheerful additions that will carry a touch of the outdoors to every room in your home!

The Four Patch Block

The Four Patch block is one of the simplest used in quilting. Four Patch blocks are made with four squares of equal size. To create a distinct pattern, two of the squares in a Four Patch block are a contrasting color from the other two squares. Usually, two squares are light and two are dark, but this does not have to be the case. In scrappy quilts, all four squares could be different colors. Four Patch blocks can be assembled in two different ways. Both ways are used for this grouping.

1. One way to create a Four Patch block is to join four separate squares. This method is usually used when you need a small number of blocks or when you want to make your blocks really scrappy. Join two squares together as shown to make one unit. Press the seam allowances open or toward the darker square. If your units aren't made from a light and dark square, wait until you are ready to join the units before pressing the seam.

2. Join two units to make one Four Patch block. If you used dark and light squares for each unit, join the units so the colors oppose each other; otherwise arrange them however you wish. Press the seam allowances to one side. If you will be joining several Four Patch blocks into a strip, press the seam allowances in opposite directions on every other block.

3. Another way to construct a Four Patch is to join two strips along the long edges to make a strip set. Press the seam allowances open. Crosscut the strip set into segments that are the width of the original strip. For example, if the strip set is constructed of 2½"-wide strips, cut 2½"-wide segments. Join two units as shown in step 2 to make the Four Patch Block.

patchwork blooms Lap Quilt

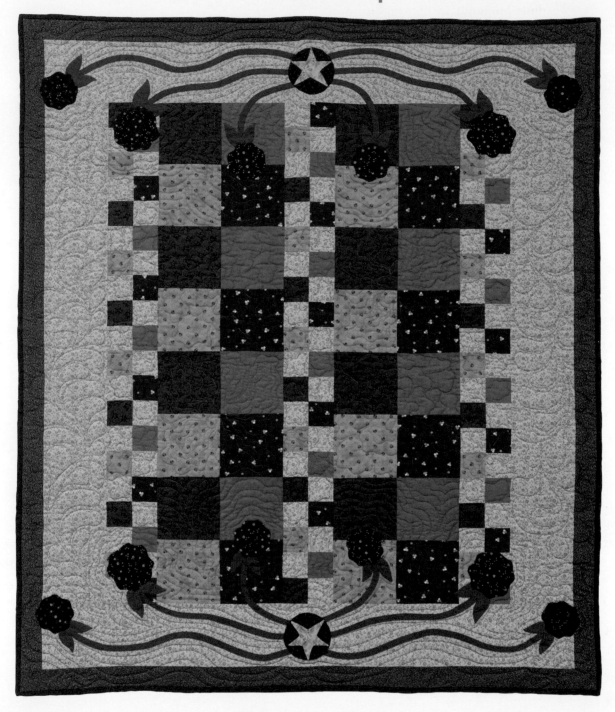

Finished Quilt: 46" x 54"
Finished Large Four Patch Block: 10" x 10"
Finished Small Four Patch Block: 4" x 4"
Machine quilted by Mindy Prohaski of Quilting on Cameo

Materials

Yardage is based on 42"-wide fabric.

½ yard *each* of medium burgundy, medium gold, medium green, and medium blue #1 fabrics for blocks

1⅓ yards of medium tan fabric for blocks and inner border

⅝ yard of dark blue fabric #1 for outer border

1 fat quarter of dark green fabric for stems and calyxes

1 fat eighth *each* of dark blue fabric #2 and dark red fabrics for small and large blooms and bloom centers

8" x 8" piece of dark purple fabric for small blooms

5" x 10" piece of medium blue fabric #2 for star circles

5" x 8" piece of dark gold fabric for stars

½ yard of dark blue fabric #3 for binding

3 yards of fabric for backing

54" x 62" piece of batting

Cutting

Cut strips across the width of the fabric unless otherwise noted. Refer to "Making Bias Stems" on page 12 to cut bias strips. All measurements include ¼"-wide seam allowances.

From the medium burgundy fabric, cut:

• 1 strip, 2½" x 42"
• 8 squares, 5½" x 5½"

From the medium gold fabric, cut:

• 1 strip, 2½" x 42"
• 8 squares, 5½" x 5½"

From the medium green fabric, cut:

• 1 strip, 2½" x 42"
• 8 squares, 5½" x 5½"

From the medium blue fabric #1, cut:

• 1 strip, 2½" x 42"
• 8 squares, 5½" x 5½"

From the *lengthwise grain* of the medium tan fabric, cut:

• 2 strips, 5½" x 42½"
• 2 strips, 5½" x 40½"
• 4 strips, 2½" x 42"

From the dark blue fabric #1, cut:

• 4 strips, 2¼" x 25½"
• 4 strips, 2¼" x 23¼"

From the fat quarter of dark green fabric, cut:

• 4 bias strips, 1" x 19"
• 4 bias strips, 1" x 14"
• 4 bias strips, 1" x 8"
• Reserve the remainder of the fabric for the leaf and calyx appliqués.

From the dark blue fabric #3, cut:

• 5 strips, 2½" x 42", for double-fold binding

Making the Four Patch Blocks

1. Follow steps 1 and 2 of "The Four Patch Block" on page 45 to make eight large Four Patch blocks from the 5½" squares. Each block should be identical and use one square of each color.

2. Follow step 3 on page 45 to make four strip sets from the 2½" x 42" strips. Each strip set will have a medium tan strip and a medium burgundy, medium gold, medium green, or medium blue #1 strip. Press the seam allowances toward the medium tan strips. From each strip set, cut 15 segments, 2½" wide. Join two different-colored segments together to make a small Four Patch block. Repeat to make a total of 30 blocks. Be sure to mix the colors to achieve a scrappy appearance.

Assembling the Quilt Top

1. Join 10 of the small Four Patch blocks together as shown to make a row. Be sure to maintain the scrappy appearance by separating like colors. Press the seam allowances in one direction. Repeat to make a total of three rows.

Make 3.

2. Join four large Four Patch blocks as shown to make a row. I arranged my blocks so that the squares were in identical positions from block to block but you could rotate yours for a different look if desired. Press the seam allowances in the opposite direction as the step 1 rows. Repeat to make a total of two rows.

Make 2.

3. Lay out the rows as shown. Join the rows. Press the seam allowances in whichever direction creates the least amount of bulk.

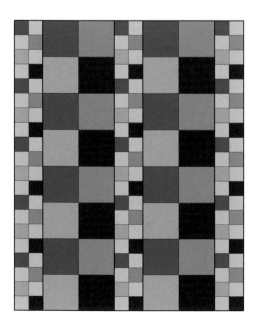

4. Join the medium tan 5½" x 40½" strips to the sides of the quilt top. Press the seam allowances toward the strips. Join the medium tan 5½" x 42½" strips to the top and bottom edges of the quilt top. Press the seam allowances toward the strips.

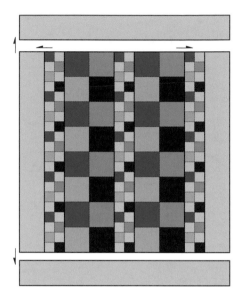

5. Join two 2¼" x 25½" dark blue #1 strips along the short ends to make one long strip. Repeat to make a total of two strips. Sew these strips to the sides of the quilt top. Press the seam allowances toward the strips. Join two 2¼" x 23¼" dark blue #1 strips along the short ends to make one long strip. Repeat to make a total of two strips. Sew these strips to the top and bottom edges of the quilt top. Press the seam allowances toward the strips.

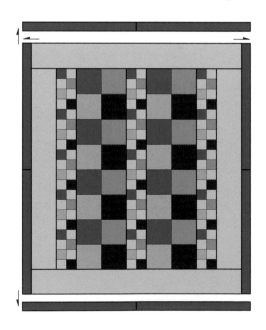

Adding the Appliqués

Use your preferred method of appliqué or refer to "Appliqué" on page 11 for more information on needle-turn hand appliqué and fusible-web machine appliqué. Refer to the diagram below for appliqué placement.

1. Refer to "Making Bias Stems" on page 12 to make stems from the bias strips. Appliqué the stems in place. The circle and bloom appliqués will cover the stem raw ends.

2. Using patterns 1–7 on pages 64 and 65 and your preferred appliqué method, make the appliqué shapes from the fabric indicated.

3. Appliqué the shapes in place, working in numerical order.

Finishing the Quilt

Refer to "Finishing Techniques" on page 13 for instructions as needed.

1. Layer the quilt top with batting and backing; baste.

2. Quilt as desired. This quilt was professionally machine quilted by a long-arm quilter. She echo quilted around the blooms and stems and quilted a large flower pattern in the open areas.

3. Use the dark blue #3 strips to bind the quilt.

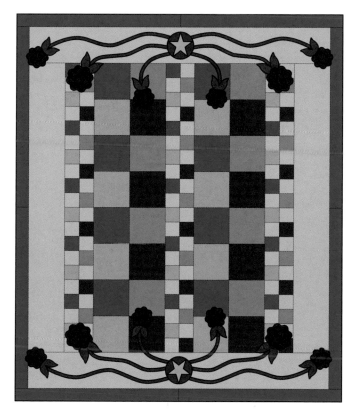

Appliqué placement

patchwork blooms Pillow

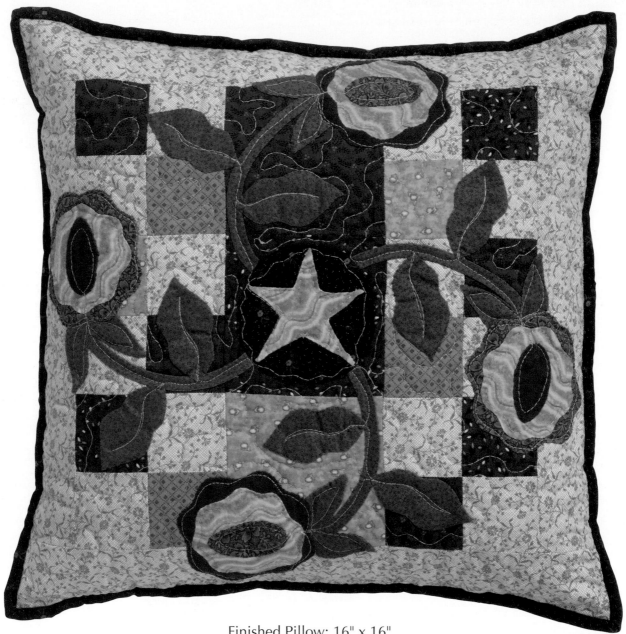

Finished Pillow: 16" x 16"
Finished Block: 4" x 4"

Materials

Yardage is based on 42"-wide fabric.

1 fat eighth *each* of medium red, medium gold, medium green, and medium blue #1 fabrics for blocks and center row

⅝ yard of medium tan fabric for blocks, background, and pillow back

1 fat eighth of dark green fabric for stems, leaves, and small calyxes

1 fat eighth of dark gold fabric for star and small blooms

7" x 9" piece of medium blue fabric #2 for large blooms and bloom centers

7" x 9" piece of dark red fabric for large blooms and bloom centers

5" x 5" piece of dark blue fabric #1 for star circle

¼ yard of dark blue fabric #2 for binding

1 fat quarter of fabric for backing

20" x 20" square of batting

16" x 16" square pillow form

Cutting

Cut strips across the width of the fabric unless otherwise noted. Refer to "Making Bias Stems" on page 12 to cut bias strips. All measurements include ¼"-wide seam allowances.

From the fat eighth of medium red fabric, cut:

• 1 square, 4½" x 4½"

• 3 squares, 2½" x 2½"

From the fat eighth of medium gold fabric, cut:

• 1 square, 4½" x 4½"

• 2 squares, 2½" x 2½"

From the fat eighth of medium blue fabric #1, cut:

• 1 square, 4½" x 4½"

• 4 squares, 2½" x 2½"

From the fat eighth of medium green fabric, cut:

• 3 squares, 2½" x 2½"

From the medium tan fabric, cut:

• 1 square, 16½" x 16½"

• 2 strips, 2½" x 16½"

• 2 strips, 2½" x 12½"

• 12 squares, 2½" x 2½"

From the fat eighth of dark green fabric, cut:

• 4 bias strips, 1" x 6"

• Reserve the remainder of the fabric for the leaf and calyx appliqués.

From the dark blue fabric #2, cut:

• 2 strips, 1½" x 42", for single-fold binding. If you prefer double-fold binding, cut strips at least 2" wide.

Assembling the Pillow Top

1. Join the 4½" squares of medium red, medium gold, and medium blue #1 as shown to make one vertical row. Press the seam allowances in one direction.

2. Referring to steps 1 and 2 of "The Four Patch Block" on page 45, use the 2½" squares of medium tan, medium red, medium gold, medium green, and medium blue #1 to make six blocks. Each block should contain two medium tan squares and two different-colored squares. Lay out the squares before sewing them into blocks to make sure no

block contains two squares of the same darker color. Do not press the center seam allowances yet.

Make 6.

3. Arrange three Four Patch blocks into one vertical row as shown. Avoid placing same-colored squares near each other to achieve a scrappy appearance. When you have determined the order of the blocks, press seam allowances of adjacent units in opposite directions. Join the blocks. Use the remaining blocks to make one additional row, reversing the placement of the medium tan squares. Press the seam allowances of both rows in the opposite direction as the step 1 row.

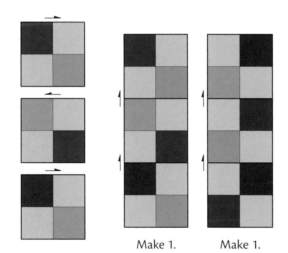

Make 1. Make 1.

4. Join the rows to the sides of the step 1 row. Press the seam allowances toward the step 1 row.

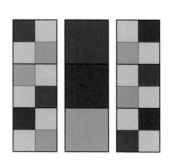 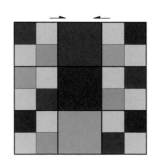

5. Join the medium tan 2½" x 12½" border strips to the sides of the pillow top. Press the seam allowances toward the border strips. Add the medium tan 2½" x 16½" strips to the top and bottom edges of the pillow top. Press the seam allowances toward the border strips.

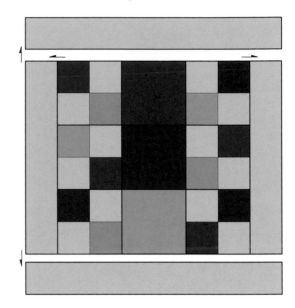

Adding the Appliqués

Use your preferred method of appliqué or refer to "Appliqué" on page 11 for more information on needle-turn hand appliqué and fusible-web machine appliqué. Refer to the diagram at right for appliqué placement.

1. Refer to "Making Bias Stems" on page 12 to make stems from the bias strips. Appliqué the stems to the pillow top. The bloom and leaf appliqués will cover the stem raw ends.

2. Using patterns 1–4 and 6–8 on pages 64 and 65 and your preferred appliqué method, make the appliqué shapes from the fabrics indicated.

3. Appliqué the shapes in place, working in numerical order.

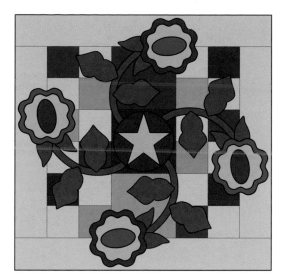

Appliqué placement

Finishing the Pillow

Refer to "Finishing Techniques" on page 13 for instructions as needed.

1. Layer the pillow top with batting and backing; baste.

2. Quilt as desired. I machine quilted my pillow in a meandering pattern in the open areas and echo quilted the stems, leaves, blooms, and the star in the circle to make them stand out. Trim the excess batting and backing even with the pillow top when the quilting is completed.

3. Lay the pillow top and back right sides together. Using a ⅛" seam allowances, stitch along *three* sides only. Leave the remaining side open for turning.

Leave this side open.

4. Turn the pillow right side out and insert the pillow form. Sew the opening closed by hand or machine. The binding will cover the stitches.

5. Use the dark blue #2 strips to bind the pillow edges.

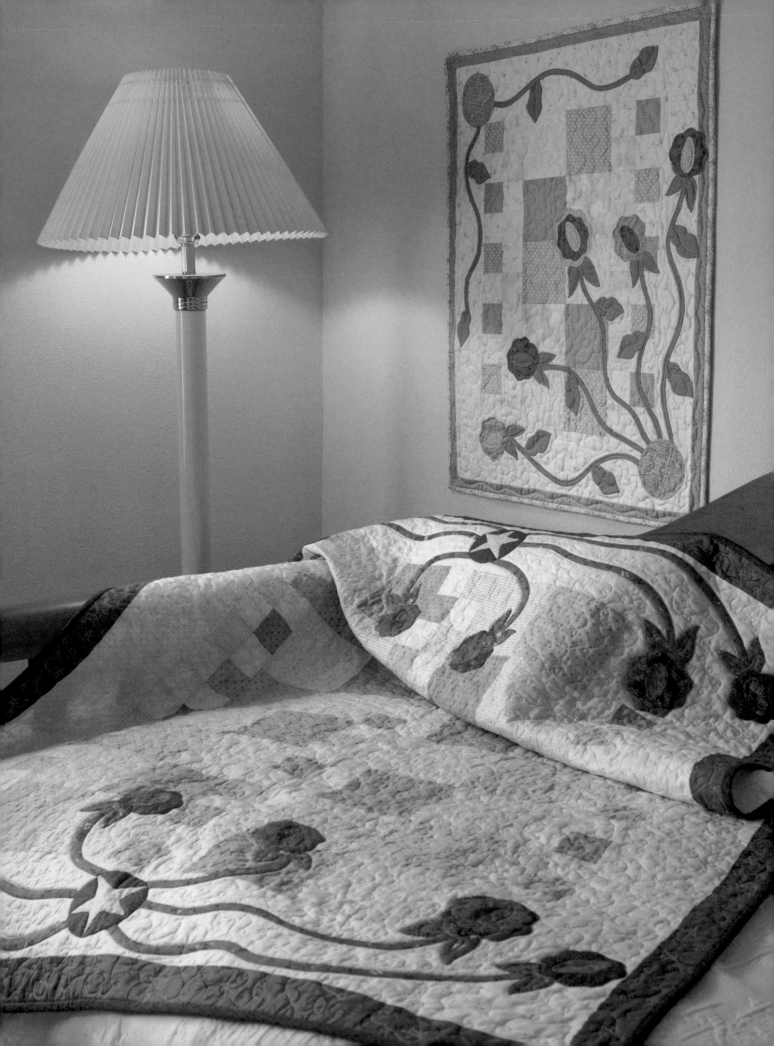

Pastel Blooms

Similar to the Patchwork Blooms projects on page 45, these pastel versions are made from large and small Four Patch blocks. Here you'll find instructions for a lap quilt and a smaller wall hanging, but you can just as easily use this color scheme to make the pillow shown in the darker colorway.

The Four Patch Block

The Four Patch block is one of the simplest used in quilting. Four Patch blocks are made with four squares of equal size. To create a distinct pattern, two of the squares in a Four Patch block are a contrasting color from the other two squares. Usually, two squares are light and two are dark, but this does not have to be the case. In scrappy quilts, all four squares could be different colors. Four Patch blocks can be assembled in two different ways. Both ways are used for this grouping.

1. One way to create a Four Patch block is to join four separate squares. This method is usually used when you need a small number of blocks or when you want to make your blocks really scrappy. Join two squares together as shown to make one unit. Press the seam allowances open or toward the darker square. If your units aren't made from a light and dark square, wait until you are ready to join the units before pressing the seam.

2. Join two units to make one Four Patch block. If you used dark and light squares for each unit, join the units so the colors oppose each other; otherwise arrange them however you wish. Press the seam allowances to one side. If you will be joining several Four Patch blocks into a strip, press the seam allowances in opposite directions on every other block.

3. Another way to construct a Four Patch is to join two strips along the long edges to make a strip set. Press the seam allowances open. Crosscut the strip set into segments that are the width of the original strip. For example, if the strip set is constructed of 2½"-wide strips, cut 2½"-wide segments. Join two units as shown in step 2 to make the Four Patch block.

pastel blooms Lap Quilt

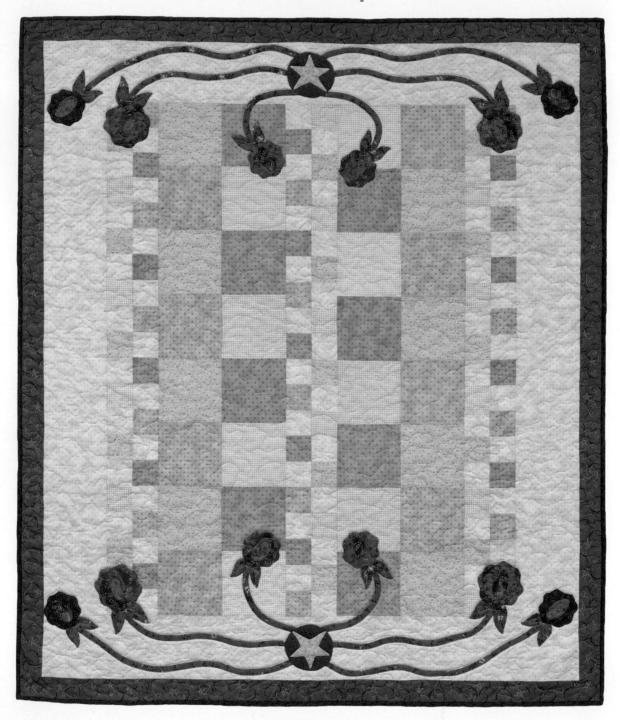

Finished Quilt: 46" x 54"
Finished Large Four Patch Block: 10" x 10"
Finished Small Four Patch Block: 4" x 4"
Machine quilted by Annette Ashbach of The Quiltmaker's Nest

Materials

Yardage is based on 42"-wide fabric.

½ yard *each* of pink, gold, light green, and medium blue fabrics for blocks

1⅓ yards of tan fabric for blocks and inner border

1⅛ yards of dark blue fabric #1 for outer border

1 fat quarter of dark green fabric for stems and small and large calyxes

1 fat eighth *each* of dark blue fabric #2 and dark red fabrics for small and large blooms and bloom centers

8" x 8" piece of dark purple fabric for small blooms

5" x 10" piece of dark blue fabric #3 for star circles

5" x 8" piece of dark gold fabric for stars

½ yard of dark blue fabric #4 for binding

3 yards of fabric for backing

54" x 62" piece of batting

Cutting

Cut strips across the width of the fabric unless otherwise noted. Refer to "Making Bias Stems" on page 12 to cut bias strips. All measurements include ¼"-wide seam allowances.

From the pink fabric, cut:

• 1 strip, 2½" x 42"

• 8 squares, 5½" x 5½"

From the gold fabric, cut:

• 1 strip, 2½" x 42"

• 8 squares, 5½" x 5½"

From the light green fabric, cut:

• 1 strip, 2½" x 42"

• 8 squares, 5½" x 5½"

From the medium blue fabric, cut:

• 1 strip, 2½" x 42"

• 8 squares, 5½" x 5½"

From the *lengthwise grain* of the tan fabric, cut:

• 2 strips, 5½" x 42½"

• 2 strips, 5½" x 40½"

• 4 strips, 2½" x 42"

From the dark blue fabric #1, cut:

• 4 border strips, 2¼" x 25½"

• 4 border strips, 2¼" x 23¼"

From the fat quarter of dark green fabric, cut:

• 4 bias strips, 1" x 19"

• 4 bias strips, 1" x 14"

• 4 bias strips, 1" x 8"

• Reserve the remainder of the fabric for the leaf and calyx appliqués.

From the dark blue fabric #4, cut:

• 5 binding strips, 2½" x 42", for double-fold binding

Making the Four Patch Blocks

1. Follow steps 1 and 2 of "The Four Patch Block" on page 55 to make eight large Four Patch blocks from the 5½" squares. Each block should be identical and use one square of each color.

2. Follow step 3 on page 55 to make four strip sets from the 2½" x 42" strips. Each strip set will have a tan strip and a pink, gold, light green, or medium blue strip. Press the seam allowances toward the medium tan strips. From each strip set, cut 15 segments, 2½" wide. Join two different color segments together to make a small Four Patch block. Repeat to make a total of 30 blocks. Be sure to mix the colors to achieve a scrappy appearance.

Assembling the Quilt Top

1. Join 10 of the small Four Patch blocks together as shown to make a row. Be sure to maintain the scrappy appearance by separating like colors. Press the seam allowances in one direction. Repeat to make a total of three rows.

Make 3.

2. Join four large Four Patch blocks as shown to make a row. I arranged my blocks so that the squares were in identical positions from block to block, but you could rotate yours for a different look if desired. Press the seam allowances in the opposite direction as the step 1 rows. Repeat to make a total of two rows.

Make 2.

3. Lay out the rows as shown. Join the rows. Press the seam allowances in whichever direction creates the least amount of bulk.

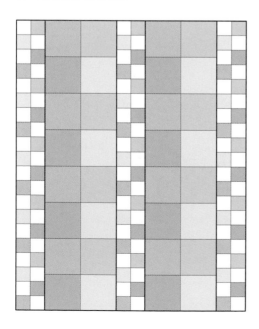

4. Join the tan 5½" x 40½" strips to the sides of the quilt top. Press the seam allowances toward the strips. Join the tan 5½" x 42½" strips to the top and bottom edges of the quilt top. Press the seam allowances toward the strips.

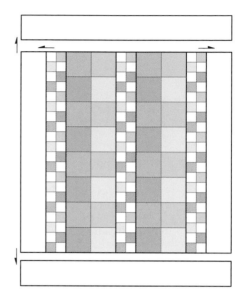

5. Join two 2¼" x 25½" dark blue strips along the short ends to make one long strip. Repeat to make a total of two strips. Sew these strips to the sides of the quilt top. Press the seam allowances toward the strips. Join two 2¼" x 23¼" dark blue #1 strips along the short ends to make one long strip. Repeat to make a total of two strips. Sew these strips to the top and bottom edges of the quilt top. Press the seam allowances toward the strips.

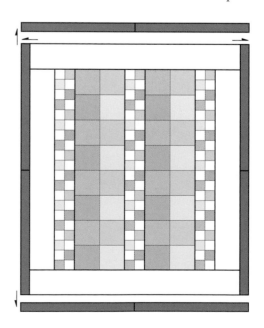

Adding the Appliqués

Use your preferred method of appliqué or refer to "Appliqué" on page 11 for more information on needle-turn hand appliqué and fusible-web machine appliqué. Refer to the diagram below for appliqué placement.

1. Refer to "Making Bias Stems" on page 12 to make stems from the bias strips. Appliqué the stems in place. The circle and bloom appliqués will cover the stem raw ends.

2. Using patterns 1–7 on pages 64 and 65 and your preferred appliqué method, make the appliqué shapes from the fabric indicated.

3. Appliqué the shapes in place, working in numerical order.

Finishing the Quilt

Refer to "Finishing Techniques" on page 13 for instructions as needed.

1. Layer the quilt top with batting and backing; baste.

2. Quilt as desired. This quilt was professionally machine quilted by a long-arm quilter. She echo quilted around the blooms and stems and quilted a large flower pattern in the open areas.

3. Use the dark blue #4 strips to bind the quilt.

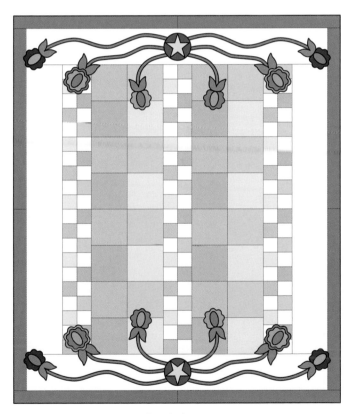

Appliqué placement

pastel blooms Wall Hanging

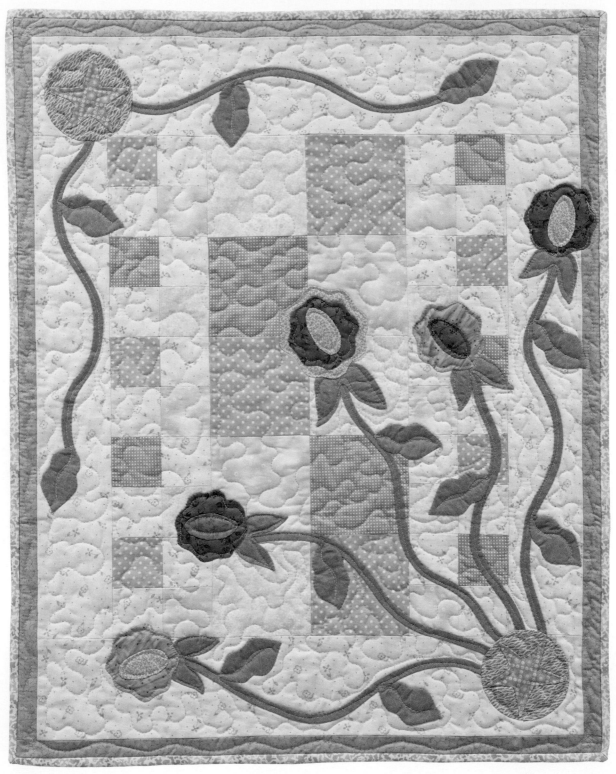

Finished Wall Hanging: 24" x 30"
Finished Block: 4" x 4"

Materials

Yardage is based on 42"-wide fabric.

⅔ yard of cream fabric for Four Patch blocks and inner border

1 fat eighth *each* of light pink, light green, light yellow, and light blue #1 fabrics for Four Patch blocks and center panel

¼ yard of medium blue fabric #1 for outer border and bloom center

1 fat quarter of medium green fabric for stems, small and large calyxes, and leaves

1 fat eighth of medium gold fabric for large blooms and bloom centers

1 fat eighth of medium pink fabric for small blooms and bloom center

1 fat eighth of medium blue fabric #2 for small blooms

1 fat eighth of medium blue fabric #3 for star circles

1 fat eighth of dark gold fabric for stars

¼ yard of light blue fabric #2 for binding

1 yard of fabric for backing

32" x 38" piece of batting

Cutting

Cut strips across the width of the fabric unless otherwise noted. Refer to "Making Bias Stems" on page 12 to cut bias strips. All measurements include ¼"-wide seam allowances.

From the fat eighth of light pink fabric, cut:

• 3 squares, 4½" x 4½"
• 5 squares, 2½" x 2½"

From the fat eighth of light yellow fabric, cut:

• 3 squares, 4½" x 4½"
• 4 squares, 2½" x 2½"

From the fat eighth of light green fabric, cut:

• 2 squares, 4½" x 4½"
• 5 squares, 2½" x 2½"

From the fat eighth of light blue fabric #1, cut:

• 2 squares, 4½" x 4½"
• 6 squares, 2½" x 2½"

From the cream fabric, cut:

• 2 strips, 4½" x 22½"
• 2 strips, 3½" x 20½"
• 20 squares, 2½" x 2½"

From the medium blue fabric #1, cut:

• 2 strips, 1¼" x 28½"
• 2 strips, 1¼" x 24"

From the fat quarter of medium green fabric, cut:

• 4 bias strips, 1" x 17"
• 3 bias strips, 1" x 15"
• Reserve the remainder of the fabric for the leaf and calyx appliqués.

From the light blue fabric #2, cut:

• 3 strips, 1½" x 42", for single-fold binding. If you prefer double-fold binding, cut strips at least 2" wide.

Assembling the Wall Hanging Top

1. Join a light pink 4½" square to each light yellow 4½" square. Repeat with the light green and light blue 4½" squares. Do not press the seam allowances yet.

Make 3.

Make 2.

2. Arrange the units from step 1 into one vertical row as shown. Alternate the colors to create a scrappy appearance. When you have determined the order of the units, press the seam allowance of adjacent units in opposite directions. Join the units to complete the center panel. Press the seam allowance in one direction.

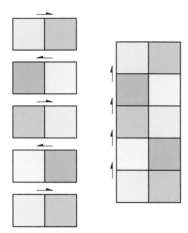

3. Referring to steps 1 and 2 of "The Four Patch Block" on page 55, use the cream, light pink, light green, light yellow, and light blue 2½" squares to make 10 blocks. Each block should be made of two cream squares and two different-colored squares. Lay out the squares before sewing them into Four Patch blocks to make sure no Four Patch block contains two squares of the same darker color. Do not press the center seam allowances yet.

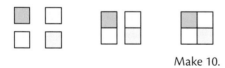

Make 10.

4. Arrange five Four Patch blocks in one vertical row as shown. To achieve a scrappy appearance, avoid placing same-colored squares near each other. Join the blocks. Use the remaining blocks to make one additional row, reversing the placement of the cream squares. Press the seam allowances of both rows in the opposite direction of the step 2 row.

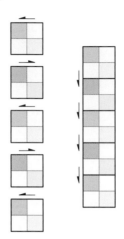

5. Join the rows to the sides of the center panel as shown. Press the seam allowances toward the center panel.

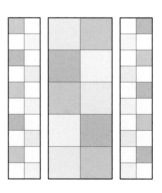

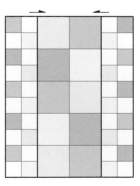

6. Join the cream 3½" x 20½" inner-border strips to the sides of the wall-hanging top. Press the seam allowances toward the center panel. Add the cream 4½" x 22½" inner-border strips to the top and bottom edges of the wall hanging. Press the seam allowances toward the center panel.

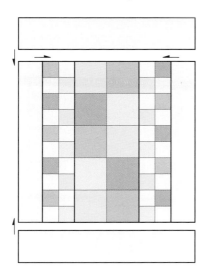

7. Join the medium blue #1 outer-border 1¼" x 28½" strips to the sides of the wall-hanging top. Press the seam allowances toward the outer border. Add the medium blue outer border 1¼" x 24" strips to the top and bottom edges of the wall-hanging top. Press the seam allowances toward the outer border.

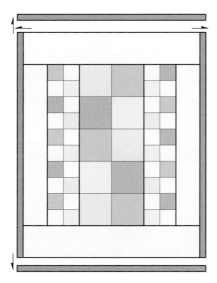

Adding the Appliqués

Use your preferred method of appliqué or refer to "Appliqué" on page 11 for more information on needle-turn hand appliqué and fusible-web machine appliqué. Refer to the diagram below for appliqué placement.

1. Refer to "Making Bias Stems" on page 12 to make stems from the bias strips. Appliqué the stems in place. The circle and bloom appliqués will cover the stem raw ends.

2. Use the patterns on pages 64 and 65 and your preferred appliqué method to make the appliqué shapes from the fabrics indicated.

3. Appliqué the shapes in place, working in numerical order.

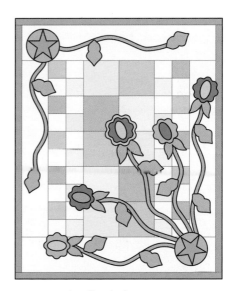

Appliqué placement

Finishing the Wall Hanging

Refer to "Finishing Techniques" on page 13 for instructions as needed.

1. Layer the wall hanging top with batting and backing; baste.

2. Quilt as desired. I machine quilted a meandering stitch in the open areas and echo quilted inside the blooms, stems, leaves, and calyxes to make them stand out.

3. Use the light blue #2 strips to bind the quilt.

1
Circle

Patchwork Blooms
Lap quilt: Cut 2 from medium blue #2.
Pillow: Cut 1 from dark blue #1.

Pastel Blooms
Lap quilt: Cut 2 from dark blue #3.
Wall hanging: Cut 2 from medium blue #3.

2
Star

Patchwork Blooms
Lap quilt: Cut 2 from dark gold.
Pillow: Cut 1 from dark gold.

Pastel Blooms
Lap quilt: Cut 2 from dark gold.
Wall hanging: Cut 2 from dark gold.

3
Large bloom

Patchwork Blooms
Lap quilt: Cut 2 from dark red and 2 from dark blue #2.
Pillow: Cut 2 from dark red and 2 from medium blue #2.

Pastel Blooms
Lap quilt: Cut 2 from dark red and 2 from dark blue #2.
Wall hanging: Cut 1 from medium gold.

4
Small bloom

Patchwork Blooms
Lap quilt: Cut 4 from dark red, 4 from dark blue #2, and 4 from dark purple.
Pillow: Cut 4 from dark gold.

Pastel Blooms
Lap quilt: Cut 4 from dark red, 4 from dark blue #2, and 4 from dark purple.
Wall hanging: Cut 3 from medium pink and 2 from medium blue #2.

Patterns do not include seam allowances.

5
Large calyx

Patchwork Blooms
Lap quilt: Cut 4 from dark green.

Pastel Blooms
Lap quilt: Cut 4 from dark green.
Wall hanging: Cut 1 from medium green.

6
Small calyx

Patchwork Blooms
Lap quilt: Cut 8 from dark green.
Pillow: Cut 4 from dark green.

Pastel Blooms
Lap quilt: Cut 8 from dark green.
Wall hanging: Cut 4 from medium green.

7
Flower center

Patchwork Blooms
Lap quilt: Cut 6 from dark blue #2 and 6 from dark red.
Pillow: Cut 2 from medium blue #2 and 2 from dark red.

Pastel Blooms
Lap quilt: Cut 6 from dark blue #2 and 6 from dark red.
Wall hanging: Cut 3 from medium gold, 1 from medium pink, and 1 from medium blue #1.

8
Leaf

Patchwork Blooms
Pillow: Cut 8 from dark green.

Pastel Blooms
Wall hanging: Cut 11 from medium green.

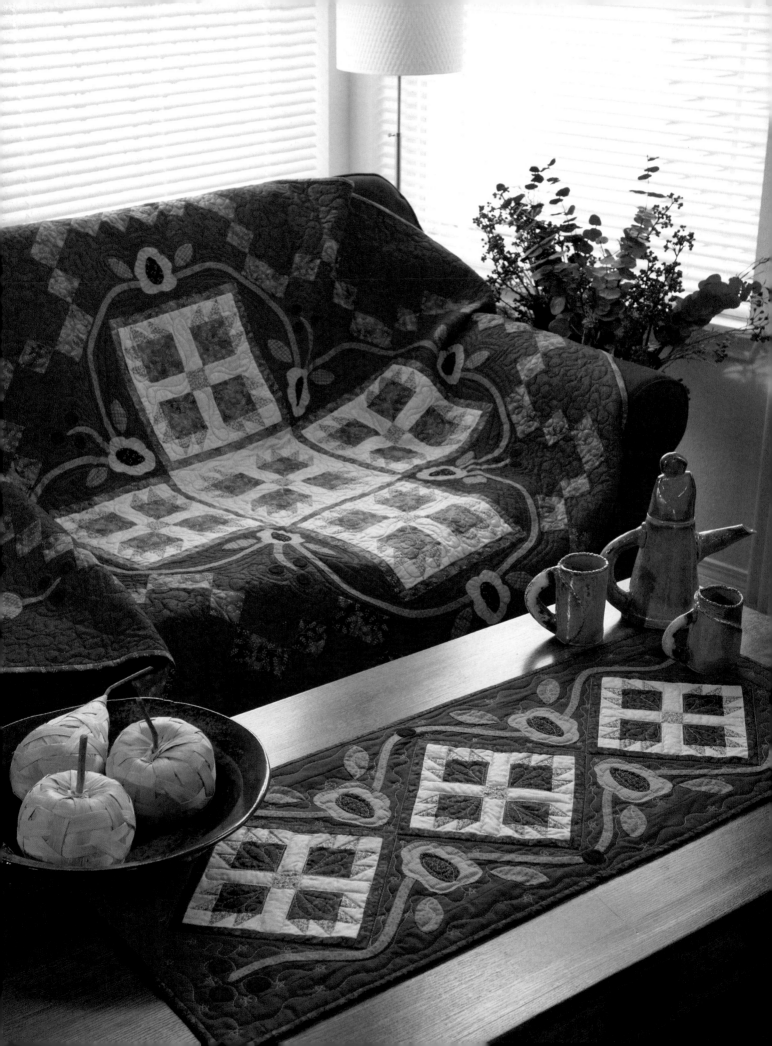

Bears in the Berry Patch

Bear's Paw blocks take center stage in this charming duo. Framed by winding vines and colorful blooms, they're sure to add a touch of country charm to your decor.

The Bear's Paw Block

The Bear's Paw block looks challenging but is actually easy to piece. Three fabrics are usually used: a darker focus fabric for the paws, a medium fabric for the claws, and a lighter fabric for the background. You can create a scrappy look by using different fabrics for each block.

1. To make one block, join a brown triangle to a tan triangle as shown to make a triangle-square unit. Make 16. Press the seam allowances toward the brown triangles.

Make 16.

2. Arrange two triangle-square units from step 1 and a tan square side by side, making sure the brown triangles are turned in the correct direction. Join the squares. Make four units. Press the seam allowances toward the brown triangles. Join two more triangle-square units as shown. Again, be sure the brown triangles are turned in the correct direction. Make four units.

Make 4. Make 4.

3. Join one of each unit from step 2 to adjoining sides of a blue square as shown. Press the seam allowances toward the blue square. Make four paw units.

Make 4.

4. Join a paw unit to each long side of a medium tan rectangle as shown to make a row. Press the seam allowances toward the paw units. Repeat to make one additional row.

Make 2.

5. Join tan rectangles to opposite sides of a brown square. Press the seam allowances toward the square.

6. Lay out the rows from steps 4 and 5 as shown. Join the rows. Press the seam allowances toward the paw rows.

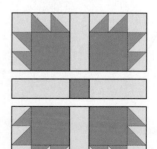

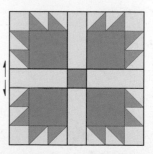

bears in the berry patch Lap Quilt

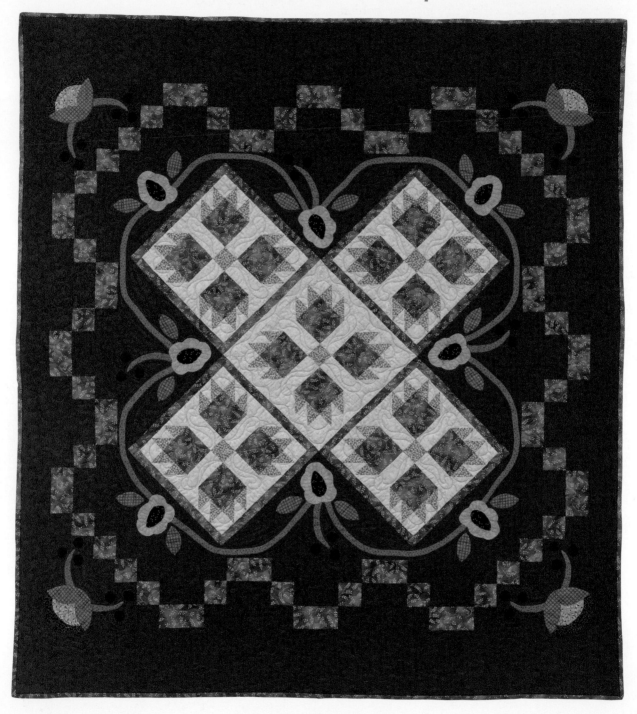

Finished Quilt: 54" x 60"
Finished Block: 12" x 12"
Machine quilted by Mindy Prohaski of Quilting on Cameo

Materials

Yardage is based on 42"-wide fabric.

3¼ yards of red fabric for setting triangles and borders

1½ yards of medium blue fabric for blocks, pieced middle border, and binding

½ yard of tan fabric for blocks

⅓ yard of brown fabric for blocks

1 fat quarter *each* of dark green fabrics #1 and #2 for stems, leaves, and calyxes

1 fat quarter of dark blue fabric #1 for flowers

1 fat eighth *each* of dark gold fabrics #1 and #2 for flowers

1 fat eighth of dark blue fabric #2 for flowers

1 fat eighth of dark red fabric for berries

3½ yards of fabric for backing

62" x 68" piece of batting

Cutting

Cut strips across the width of the fabric unless otherwise noted. Refer to "Making Bias Stems" on page 12 to cut bias strips. All measurements include ¼"-wide seam allowances.

From the brown fabric, cut:

• 40 squares, 2⅜" x 2⅜"; cut in half diagonally to yield 80 half-square triangles

• 5 squares, 2" x 2"

From the tan fabric, cut:

• 40 squares, 2⅜" x 2⅜"; cut in half diagonally to yield 80 half-square triangles

• 20 rectangles, 2" x 5"

• 20 squares, 2" x 2"

• 2 strips, 1¼" x 12½"

• 2 strips, 1¼" x 11"

From the medium blue fabric, cut:

• 1 strip, 4½" x 42"

• 10 strips, 2½" x 42"

• 20 squares, 3½" x 3½"

• 8 strips, 1¼" x 12½"

• 8 strips, 1¼" x 11"

From the red fabric, cut:

• 2 strips, 4½" x 42"

• 4 strips, 2½" x 42"

• 1 square, 18¼" x 18¼"; cut twice diagonally to yield 4 quarter-square triangles

• 2 squares, 9⅜" x 9⅜"; cut in half diagonally to yield 4 half-square triangles

• 4 squares, 6½" x 6½"

• 4 strips, 6¼" x 24½"

• 12 squares, 4½" x 4½"

• 4 strips, 3¼" x 30¼"

• 2 strips, 1½" x 36½"

• 2 strips, 1½" x 34½"

From the fat quarter of dark green fabric #1, cut:

• 8 bias strips, 1" x 17"

• Reserve the remainder of the fabric for the small stems.

Making the Bear's Paw Blocks

1. Refer to steps 1–7 of "The Bear's Paw Block" on page 67 to make five Bear's Paw blocks using the brown triangles and 2" squares; the tan triangles, 2" x 5" rectangles, and 2" squares; and the medium blue 3½" squares.

2. Join 1¼" x 11" medium blue border strips to opposite sides of four blocks. Press the seam allowances toward the strips. Join the 1¼" x 12½" medium blue strips to the top and bottom of the blocks. Press the seam allowances toward the strips.

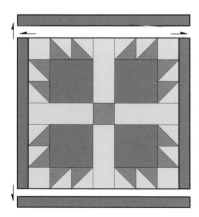

Make 4.

3. Refer to step 2 to join the tan 1¼"-wide strips to the remaining block.

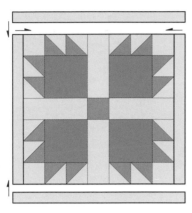

Make 1.

Assembling the Quilt Top Center

1. Join red quarter-square triangles to opposite sides of a blue-bordered block to make a row. Make sure you line up the 90° angle of the triangle with the bottom corners of the block. A small amount of the triangle will extend past the block at the top. Do not trim off the excess. Press the seam allowances toward the block. Repeat to make one additional row.

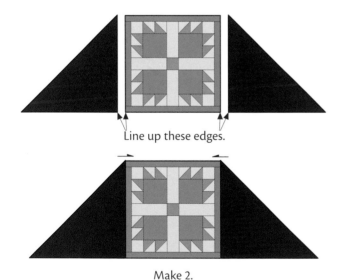

Line up these edges.

Make 2.

2. Join the remaining three blocks in a row with the tan-bordered block in the center. Press the seam allowances toward the blue-bordered blocks.

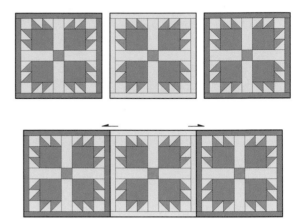

3. Join the step 1 rows to the long edges of the step 2 row, aligning the seams of the blocks. Once again, there will be a small amount of the triangle that will extend beyond the ends of the center row. Do not trim these off. Press the seam allowances toward the outer rows.

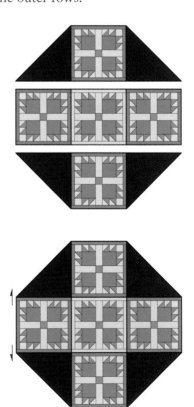

4. Center and pin red 9⅜" half-square triangles to the raw edges of the four outside blocks. The point of the triangle should be right in the center of the blocks. The outer points of the triangles will extend beyond the edges of the blocks. Stitch the triangles in place. Press the seam allowances toward the triangles. Trim the extending points so the edges are even and the piece is square.

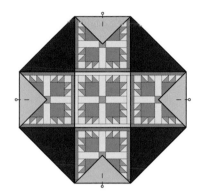

Center and pin in place.

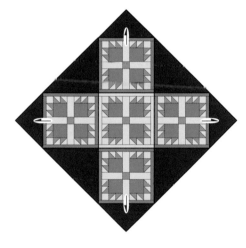

Adding the Borders

1. Join the red 1½" x 34½" strips to opposite sides of the quilt center. Press the seam allowances toward the strips. Add the red 1½" x 36½" strips to the top and bottom of the quilt center. Press the seam allowances toward the strips.

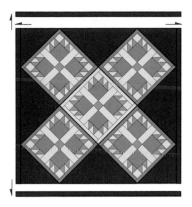

2. To make the pieced middle border, join two red and one medium blue 4½" x 42" strips along the long edges as shown to make a strip set. Press the seam allowances toward the blue strip. Crosscut the strip set into 12 segments, 2½" wide.

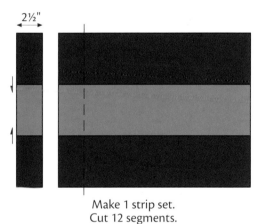

2½"

Make 1 strip set.
Cut 12 segments.

3. Join a red 2½" x 42" strip to a medium blue 2½" x 42" strip along the long edges to make a strip set. Make four. Press the seam allowances toward the medium blue strips. Crosscut the strip sets into 48 segments, 2½" wide.

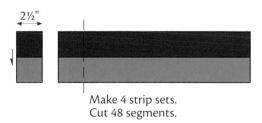

2½"

Make 4 strip sets.
Cut 48 segments.

4. Join two segments from step 3 as shown to make a four-patch unit. Make 24. Press the seam allowance in either direction.

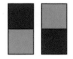 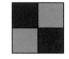

Make 24.

5. Join a four-patch unit to opposite sides of a red 4½" square as shown. Make sure the four-patch units are positioned correctly. Repeat to make a total of 12 units. Press the seam allowances toward the four-patch units.

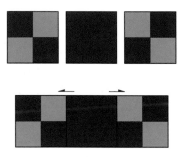

Make 12.

6. Join a unit from step 2 to the top of each of the units from step 5. Do not press the seam allowances yet.

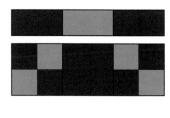

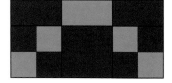

Make 4.

7. Lay out three units from step 6 in a horizontal row. Press the horizontal seam allowances on the two outer units in the opposite direction as the middle unit. Join the units together and press the seam allowances toward the middle unit. Repeat to make a total of four rows.

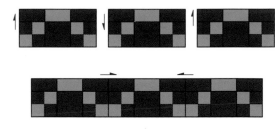

Make 4.

8. Join a row from step 7 to opposite sides of the quilt top with the four-patch units toward the quilt center. Press the seam allowances toward the quilt center. Add red 6½" squares to the ends of the two remaining rows. Join these rows to the top and bottom of the quilt top, positioning the four-patch units toward the quilt center.

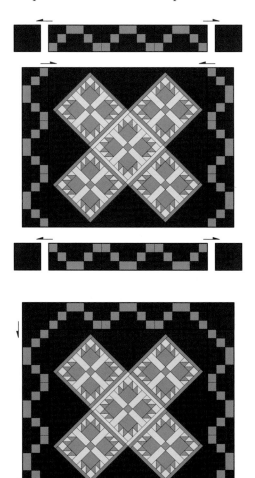

9. Join two red 6¼" x 24½" strips along the short ends to make one long strip. Repeat to make a total of two strips. Press the seam allowances in either direction. Sew these strips to the top and bottom of the quilt top. Press the seam allowance toward the strips. Join two red 3¼" x 30¼" strips along the short ends to make one long strip. Repeat to make a total of two strips. Sew these strips to the sides of the quilt top. Press the seam allowances toward the strips.

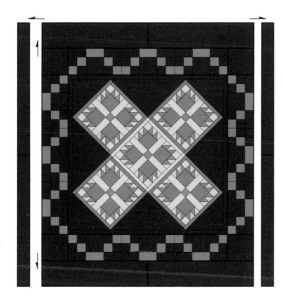

Adding the Appliqués

Use your preferred method of appliqué or refer to "Appliqué" on page 11 for more information on needle-turn hand appliqué and fusible-web machine appliqué. Refer to the diagram at right for appliqué placement.

1. Refer to "Making Bias Stems" on page 12 to make stems from the bias strips. Appliqué the stems in place. The flower and leaf appliqués will cover the stem raw ends.

2. Using the patterns on pages 78 and 79 and your preferred appliqué method, make the appliqué shapes from the fabrics indicated.

3. Appliqué the shapes in place, working in numerical order.

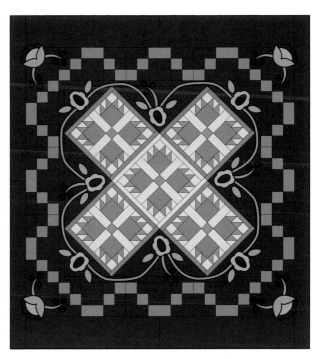

Appliqué placement

Finishing the Quilt

Refer to "Finishing Techniques" on page 13 for instructions as needed.

1. Layer the quilt top with batting and backing; baste.

2. Quilt as desired. This quilt was professionally machine quilted by a long-arm quilter. She echo quilted around the flowers and berries and did a large flower design inside the Bear's Paw blocks. The border was quilted in a free-motion meandering pattern.

3. Use the remaining six medium blue strips to bind the quilt.

bears in the berry patch Table Runner

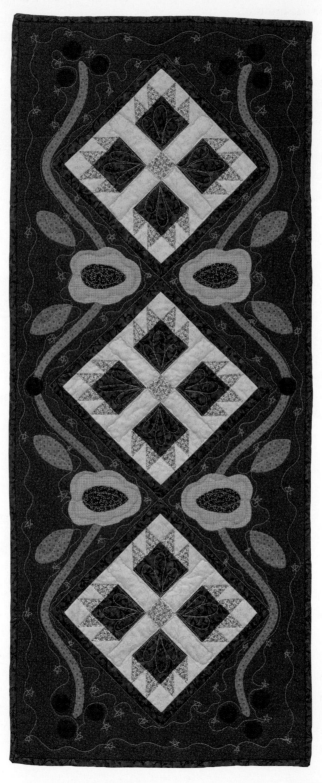

Finished Table Runner: 15¼" x 37⅞"
Finished Block: 8" x 8"

Materials

Yardage is based on 42"-wide fabric.

⅔ yard of medium red fabric for background

⅜ yard of dark blue fabric #1 for blocks and binding

5" x 10" piece of dark blue fabric #2 for flowers

¼ yard of light tan fabric for blocks

¼ yard of medium brown fabric for blocks

1 fat quarter of dark green fabric for stems and leaves

1 fat eighth of dark gold fabric for flowers

6" x 12" piece of dark red fabric for berries

⅝ yard of fabric for backing

19" x 42" piece of batting

Cutting

Cut strips across the width of the fabric unless otherwise noted. Refer to "Making Bias Stems" on page 12 to cut bias strips. All measurements include ¼"-wide seam allowances.

From the medium brown fabric, cut:

- 24 squares, 1⅞" x 1⅞"; cut in half diagonally to yield 48 half-square triangles
- 3 squares, 1½" x 1½"

From the light tan fabric, cut:

- 24 squares, 1⅞" x 1⅞"; cut in half diagonally to yield 48 half-square triangles
- 12 rectangles, 1½" x 3½"
- 12 squares, 1½" x 1½"

From the dark blue fabric #1, cut:

- 12 squares, 2½" x 2½"
- 3 strips, 1½" x 42", for single-fold binding. If you prefer double-fold binding, cut strips at least 2" wide.
- 6 strips, 1" x 8½"
- 6 strips, 1" x 7½"

From the medium red fabric, cut:

- 1 square, 12⅝" x 12⅝"; cut twice diagonally to yield 4 quarter-square triangles
- 2 squares, 6⅝" x 6⅝"; cut in half diagonally to yield 4 half-square triangles
- 2 strips, 2¼" x 34⅜"
- 2 strips, 2¼" x 15¼"

From the fat quarter of dark green fabric, cut:

- 4 bias strips, 1" x 19"
- Reserve the remainder of the fabric for the leaf appliqués.

Making the Bear's Paw Blocks

1. Refer to "The Bear's Paw Block" on page 67 to make three blocks using the medium brown triangles and the 1½" squares; the light tan triangles, the 1½" x 3½" rectangles, and the 1½" squares; and the dark blue 2½" squares.

2. Join the shorter dark blue #1 border strips to opposite sides of the blocks. Press the seam allowances toward the strips. Join the longer dark blue #1 strips to the top and bottom of the blocks. Press the seam allowances toward the strips.

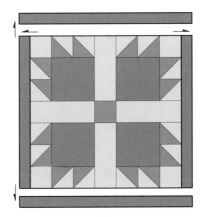

Make 4.

Assembling the Table Runner Top

1. Join medium red quarter-square triangles to opposite sides of a block. Make sure you line up the 90° angle of the triangles with the corners of the block as shown. A small amount of the triangle will extend past the block. Do not trim off the excess. Press the seam allowances toward the block. This will be the center row.

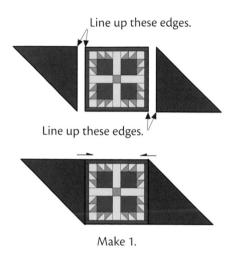

Line up these edges.

Line up these edges.

Make 1.

2. Join a medium red quarter-square triangle to one side of each of the remaining blocks, lining up the 90° angle as before. Press the seam allowances toward the triangles. Center and pin a medium red half-square triangle to the opposite side of these blocks. The point of the triangles should be right in the center of the blocks. The outer points of the triangles will extend beyond the edges of the blocks. Stitch the triangles in place. Do not trim off the excess. Press the seam allowances toward the triangles. These will be the outer rows.

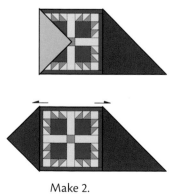

Make 2.

3. Join the rows as shown, matching the block seams. Once again, a small amount of the triangle will extend beyond the ends of the rows. Do not trim these bits off. Press the seam allowances toward the center row.

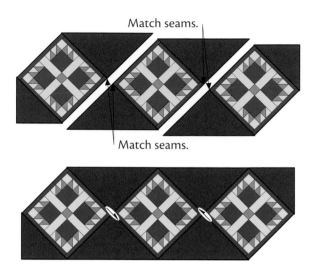

Match seams.

Match seams.

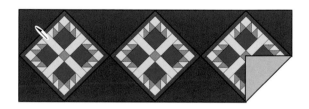

4. Join the remaining two medium red half-square triangles to the ends of the table-runner top, centering them as you did in step 2. Press the seam allowances toward the blocks. Trim the extending points so the edges are even.

5. Join the medium red 2¼" x 34⅜" strips to the long sides of the table-runner top. Press the seam allowances toward the strips. Add the medium red 2¼" x 15¼" strips to the short sides of the table-runner top. Press the seam allowances toward the strips.

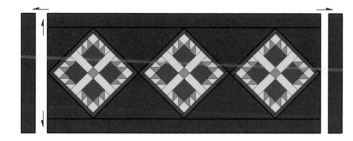

Adding the Appliqués

Use your preferred method of appliqué or refer to "Appliqué" on page 11 for more information on needle-turn hand appliqué and fusible-web machine appliqué. Refer to the diagram below for appliqué placement.

1. Refer to "Making Bias Stems" on page 12 to make stems from the bias strips. Appliqué them in place.

The flower appliqués will cover the raw ends of the strips in the center; turn the raw edges on the short ends of the table runner to the inside of the stems and appliqué them in place.

2. Using patterns 2, 3, 4, and 9 on page 78 and your preferred appliqué method, make the appliqué shapes from the fabrics indicated.

3. Appliqué the shapes in place, working in numerical order.

Finishing the Table Runner

Refer to "Finishing Techniques" on page 13 for instructions as needed.

1. Layer the table-runner top with batting and backing; baste.

2. Quilt as desired. I quilted inside the blocks, tracing the outline. I also quilted a free-motion fan design in the bottom portion of the paw units. I echo quilted inside the flowers and leaves. The remainder of the quilt top was quilted with free-motion meandering and stars.

3. Use the dark blue #1 strips to bind the quilt.

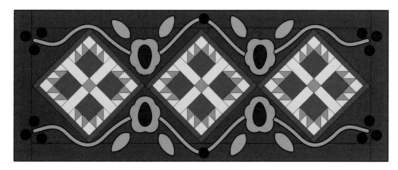

Appliqué placement

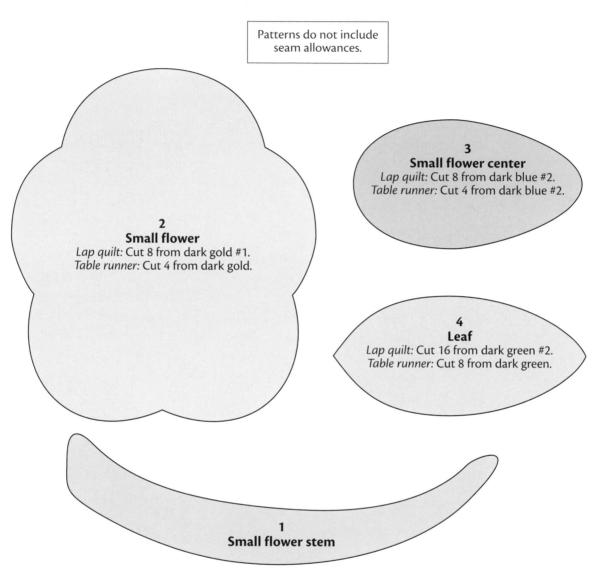

Patterns do not include seam allowances.

3
Small flower center
Lap quilt: Cut 8 from dark blue #2.
Table runner: Cut 4 from dark blue #2.

2
Small flower
Lap quilt: Cut 8 from dark gold #1.
Table runner: Cut 4 from dark gold.

4
Leaf
Lap quilt: Cut 16 from dark green #2.
Table runner: Cut 8 from dark green.

1
Small flower stem

Lap quilt: Cut 4 from dark green #1.

9
Berry

Lap quilt: Cut 36 from dark red.
Table runner: Cut 14 from dark red.

Patterns do not include
seam allowances.

5
Large flower
Lap quilt: Cut 4 from dark blue #1.

6
Large flower center
Lap quilt: Cut 4 from dark gold #2.

7
Large flower stem

Lap quilt: Cut 4 from dark green #1.

8
Large flower calyx
Lap quilt: Cut 4 from dark green #2.

About the Author

Deanne Eisenman caught the quilting bug by taking a beginner's class for something to do. She hasn't looked back since. Any other hobby paled in comparison. When she could not find a pattern she wanted in a quilt shop, out came the graph paper and pencil, and a new design was born. Deanne began her pattern company, Snuggles Quilts, in 2003, and has been success-fully self-publishing her patterns ever since. One of her quilts was featured in the *American Patchwork and Quilting 2007 Calendar* (the month of May).

Deanne lives and works from her home in Osage, Iowa. Her family includes her husband, Craig, and two very active teenagers, Alyssa and Mitchell. Also at home is the company namesake, Snuggles the cat. Although not an inspiration for any design, Snuggles likes to lie on all the quilt samples and excess batting in the sewing room! Starting the pattern company and writing this book have been a dream come true for Deanne. It's great to go to work every day and love what you are doing!